HOCKEY IN
SPRINGFIELD

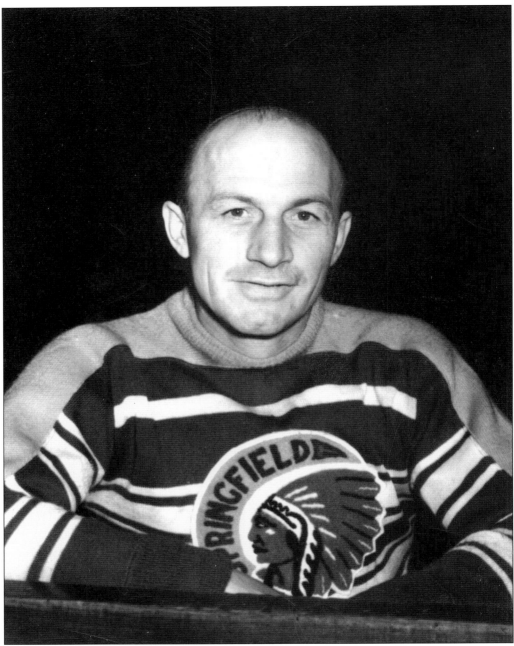

EDDIE SHORE IS SPRINGFIELD HOCKEY. Eddie Shore was associated with Springfield hockey for parts of five decades (1939–1976). He was a player, coach, manager, owner, and savior of the Springfield Indians.

HOCKEY IN SPRINGFIELD

Jim Mancuso

Published by Arcadia Publishing
Charleston SC, Chicago IL, Portsmouth NH, San Francisco CA

Printed in Great Britain

Library of Congress Catalog Card Number: 2005931821

For all general information contact Arcadia Publishing at:
Telephone 843-853-2070
Fax 843-853-0044
E-mail sales@arcadiapublishing.com
For customer service and orders:
Toll-Free 1-888-313-2665

Visit us on the Internet at http://www.arcadiapublishing.com

*In memory of the great Eddie Shore
(1902–1985), "the Edmonton Express."*

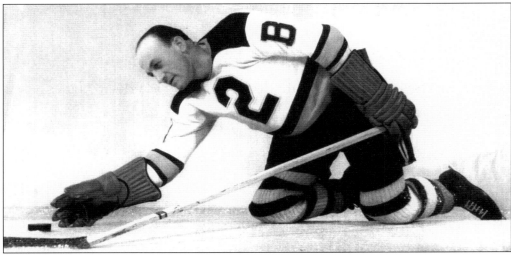

EDDIE SHORE. Shore is one of the greatest players of all time.

CONTENTS

ACKNOWLEDGMENTS

The images in this book have been provided courtesy of Ernie Fitzsimmons, the Hockey Hall of Fame in Toronto, Eddie "Ted" Shore Jr., and the Springfield Falcons Hockey Club. I would like to thank Craig Campbell (manager of the Hockey Hall of Fame Resource Center and Archives) and Edwin Duane Isenberg and David Nackley for their technical guidance and work on the illustrations in this book. The photographers responsible for the incredible images of Springfield Falcons players are Dantes Paul Anger and Michael Beecher.

I was helped directly through the Springfield Falcons office by Bruce Landon (president and general manager), Kevin Crawley (manager of media relations and internet services), and Carole Appleton (assistant to the general manager and manager of community relations).

The statistics in this book were obtained from American Hockey League (AHL) media guides (1951–2005), Ernie Fitzsimmons, the Hockey Hall of Fame Archives in Toronto, Ralph Slate's Hockey Database (www.hockeydb.com), the Society for International Hockey Research, and *Total Hockey: The Official Encyclopedia of the National Hockey League* (second edition).

Other resources include the following: *The Clinton Comets: An EHL Dynasty* by Jim Mancuso and Fred Zalatan; the Connecticut Valley Historical Society (John O'Connor); Eastern Amateur Hockey League Press and Radio Guide (1951–1952); Ernie Fitzsimmons; *Hockey in Syracuse* by Jim Mancuso; *The Hockey News* (1947–2005); Sam Pompei (SHHOF); *Eddie Shore and his Springfield Indians*, a WGBY video documentary production (2001); Eddie "Ted" Shore Jr; *The Sporting News Hockey Guide* (1967–1981); the *Springfield Daily News* (1926–1994); the *Sunday Morning Union* and *Sunday Republican* (1967–1968); and *The Complete Historical and Statistical Reference Guide to the World Hockey Association* (seventh edition) by Scott Surgent.

Please Note: SHHOF signifies that the individual is a member of the Springfield Hockey Hall of Fame; Bill Summerhill, who does not have an individual caption in this book, is 10th all-time in points (270) and goals (114) in Indians/Kings history; and The Springfield NHL and WHA affiliations cited in this book are official working agreements between Springfield and a major league club.

The Springfield Indians/Kings information in this book was reviewed for historical accuracy by Eddie "Ted" Shore Jr.

A special thanks goes to my mother, Joan Mancuso, ticket sales representative at the Utica Memorial Auditorium, who allowed me free admission into hockey games in the 1970s and early 1980s.

INTRODUCTION

Springfield celebrates the 80th anniversary of its first professional hockey team during the 2005–2006 season. The tradition started in 1926–1927 when the Springfield Indians were inaugural members of the Canadian-American Hockey League (CAHL). The Indians were the New York Rangers farm team from the 1926–1927 season until the beginning of the 1932–1933 season, when the Rangers pulled the team out of Springfield. John Beattie, Lorne Chabot, Art Chapman, Cecil Dillon, Norm Gainor, Leroy Goldsworthy, Ott Heller, Gord Pettinger, and Earl Seibert were assigned to Springfield by the Rangers. In 1935–1936, a second CAHL version of the Springfield Indians was born when the Quebec Castors (Beavers) club transferred to Springfield. The new Indians were affiliated with the Montreal Canadiens (NHL). The Indians spent seven full seasons in the CAHL and share the all-time record for winning the most Fontaine Cups with three (1926–1927, 1927–1928, and 1930–1931).

In 1936–1937, the Indians helped form the American Hockey League (known as the International-American Hockey League at the time). Prior to the 1939–1940 season, NHL legend Eddie Shore purchased the Springfield team (and would own it through the 1975–1976 season). The club would have two hiatuses during Shore's dominion: from 1942 to 1946, when the club's home rink was taken over by the U.S. Army Quartermaster Corps during World War II; and from 1951 to 1954, when the club was in Syracuse. During the early 1950s absence of the AHL Indians, Shore put an Eastern Amateur Hockey League (EAHL) team in Springfield and named it the Springfield Indians. The new Indians competed in the EAHL from 1951 to 1953 and then played in the Quebec Hockey League (QHL) in 1953–1954. The EAHL (now known as the Eastern Hockey League [EHL]) resurfaced in Springfield for part of the 1972–1973 season with the New England Blades.

The Springfield Indians became the only team in the history of the AHL to win three consecutive Calder Cup championships (1959–1960, 1960–1961, and 1961–1962). In 1960–1961, Springfield became only the second team in AHL Calder Cup playoff history to have a perfect postseason record (8-0). During the three championship seasons, the team compiled a 137-67-10 (.664 winning percentage [pct]) regular season and a 24-5 (.828 pct) playoff record.

Jack Kent Cooke, owner of the NHL expansion Los Angeles Kings, purchased the rights to the Springfield players in 1967–1968 and began leasing the AHL franchise from Shore until midway through the 1974–1975 season. During this period, the team was known as the Springfield Kings. Hall-of-Famer Billy Smith, Butch Goring, Bruce Landon, Poul Popiel, and Jean Potvin were among the star players that skated in Springfield courtesy of Los Angeles. The Springfield Kings

made AHL history in 1970–1971 by becoming the first team to win a Calder Cup championship with a losing regular season record. In 1974–1975, the Kings (NHL) threatened to pull their players out of Springfield mid-season due to large money losses incurred over the current and previous two seasons. Shore worked out an agreement with Los Angeles (NHL), whereby Shore would now cover the operation costs of the team in order to keep the Los Angeles–owned players in town until the end of the season. Cooke was still responsible for paying his players, coach, and other hockey personnel. Despite the adversity, Springfield (renamed the Indians by Shore) won the Calder Cup that season. Shore sold the team after the 1975–1976 campaign.

The New England Whalers brought major-league hockey to Springfield in the 1970s as the World Hockey Association (WHA) and then the National Hockey League (NHL) came to town. The Whalers, known as Hartford in 1979–1980, played one full season (1978–1979) and four partial seasons (1973–1974, 1974–1975, 1977–1978, and 1979–1980) in Springfield. Hockey Hall-of-Famers Gordie Howe and Dave Keon, Mark and Marty Howe, Andre Lacroix, and U.S. Hockey Hall-of-Famers Larry Pleau and Tim Sheehy all skated with the Whalers while the team was based in Springfield. In the early 1990s, the Springfield Indians won back-to-back Calder Cups with two different affiliates—the New York Islanders (1989–1990) and the Hartford Whalers (1990–1991). The 1993–1994 season was the last for the storied Indians franchise (AHL) after playing over a half-century in Springfield. The Indians won seven Calder Cups, which tied for the second most of all-time at that time.

The Springfield Falcons, formed in 1994–1995, carry on the city's great hockey legacy. The team has experienced success on the ice capturing two division titles and two regular season conference championships (1995–1996 and 1997–1998). The Falcons have established themselves as a "hotbed" of goaltending excellence, as a number of outstanding netminders have donned the pads for the club: Sylvain Daigle (three-time United Hockey League [UHL] champion); Robert Esche (NHL's 2002–2003 William Jennings Trophy winner [lowest goals against average—GAA]); Nikolai Khabibulin (2003–2004 Stanley Cup winner); Scott Langkow (shared the AHL's 1995–1996 Hap Holmes Memorial Award [Outstanding Team Goaltender(s)] and won the 1997–1998 Baz Bastien Memorial Award [Best Goaltender]); and Manny Legace (shared the AHL's 1995–1996 Hap Holmes Memorial Award and won the 1995–1996 Baz Bastien Memorial Award). The team also had its share of offensive stars: Daniel Briere (AHL all-star and AHL all-rookie team selection); Jean Guy Trudel (three-time AHL all-star); and Rob Murray (second all-time in penalty minutes [PIM] in AHL history).

The Falcons have provided area fans with a high caliber of hockey. They have established themselves as one of the top sporting attractions in Springfield, adding to the city's rich hockey history.

ONE

The Canadian-American Hockey League

Professional hockey was born in Springfield in 1926, when the Indians became inaugural members of the Canadian-American Hockey League (CAHL). George F. Sears, manager of Springfield's new ice arena at the Eastern States Coliseum, also became manager of Springfield's new hockey team. The Coliseum was built in 1916 but did not have ice until 1926. The name "Indians" was chosen from a name-the-team contest in the local newspapers. Springfield became the farm club of the New York Rangers, an NHL expansion team in 1926–1927. The Rangers sent Frank Carroll to coach the Indians.

Carroll, who would pilot the team through 1932–1933, guided the Indians to a second place finish in 1926–1927 (14-13-5 record). In the postseason, the Indians beat Quebec 2-0 (1-0 and 1-0), in a two-game total-goal semifinal. In the three-game total-goal series finals, the Indians beat New Haven 8-4 (4-0, 3-1, 1-3) and captured the Henri Fontaine Cup (named in honor of the president and owner of the Quebec CAHL franchise who passed away in the middle of the loop's inaugural season). After the CAHL playoffs, an arrangement was made for Springfield to play a three-game total-goal series against the Canadian Professional Hockey League (CPHL) champion London Panthers for the minor-league hockey championship of the east. The Indians prevailed 11-7 (3-1, 6-3, 2-3).

In 1927–1928, Springfield won the CAHL's regular season title with a 24-13-3 record and was given an automatic berth in the playoff finals. The Indians won their second consecutive Fontaine Cup by beating Quebec 11-7 in a four-game total-goal series (1-2, 1-2, 4-3, 5-0). Springfield's Clark Whyte led the CAHL in scoring with 30 points.

In their third CAHL campaign, the Indians finished fourth out of six teams and had their first losing record (13-14-13). The club also missed the postseason for the first time. The tribe sank even further in the CAHL standings in 1929–1930, finishing in last place out of five teams with a 15-23-2 record. The club, however, boasted the CAHL's leading goal scorer in Gene Carrigan (28).

Springfield had its best CAHL campaign in 1930–1931, with a 29-9-2 record (.750 pct), winning the regular season title for the second time and earning a direct berth in the playoff

finals. In the postseason, the Indians captured their third Fontaine Cup. The locals beat Boston three games to two (2-2, 3-4, 3-2, 2-6, 1-1, 3-2, 3-2) in a best-of-five series. The two contests that resulted in ties were due to the games being called because of their length. Game one of the series, on March 27, was the longest game in professional hockey history at the time, lasting 160 minutes and nine periods. Springfield's Orville Heximer won the CAHL scoring title (61 points) that season.

The Indians followed up their "worst to first season" with a "first to worst season" as they finished in the CAHL basement with a 10-25-5 record in 1931–1932.

At the beginning of the 1932–1933 season, the Springfield organization was in financial distress. The Indians failed to meet the deadline on their rent to the Coliseum and satisfied only a fraction of their monetary obligations to the New York Rangers. The Indians' debacle, brought on in part by low attendance, prompted a series of emergency meetings between Coliseum owners, Indians' management, and the Rangers (NHL). New York (NHL), who paid the salaries of the Springfield players, felt that further financing of the local entry could not be done without the incurring of great losses (the Big Apple organization reportedly lost $16,000 in Springfield already that season). A last ditch proposition made by New York was met with approval by the Indians, but was not accepted by the Eastern States Exposition company. The proposal was for the Eastern States Exposition company to make further concessions on the rent of the Coliseum building. On December 21, 1932, New York announced the pulling of its team out of Springfield and out of the CAHL. The Indians' last game was on December 17, and the club's final record was 6-5-2. Springfield did not have professional hockey for the next two seasons (1933–1934 and 1934–1935).

In 1935–1936, J. Lucien Garneau moved his Quebec Castors to Springfield and renamed the team the Springfield Indians. The "new" Indians were affiliated with Montreal (NHL). Hall-of-Famer Georges Boucher piloted the team. The locals finished in third place out of five with a 21-22-5 mark. Providence defeated the Indians in a three-game total-goal series 9 to 7 (2-3, 3-2, 4-2) in the semifinals.

Springfield shares the record for the most Fontaine Cup championships (three, with Boston and Providence) in CAHL history. In their eight seasons in the league (1926–1933, 1935–1936), the Indians complied a 132-124-37 record (.514 pct).

CLINT SMITH. Inducted into the Hockey Hall of Fame in 1991, Smith played 11 seasons in the NHL (1936–1947) and compiled 397 points and 161 goals in 483 games. The center was a member of the 1939–1940 Stanley Cup–winning Rangers and twice won the Lady Byng Trophy (Most Gentlemanly Player, 1938–1939 and 1943–1944). He skated in 12 games for the Indians in 1932–1933.

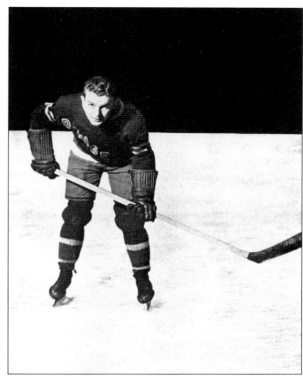

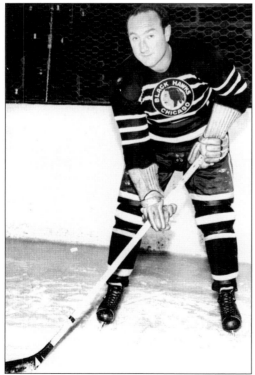

EARL SEIBERT. Inducted into the Hockey Hall of Fame in 1963, Seibert played two years with the Indians (1929–1931) and earned 32 points, 20 goals, and 180 PIM in 78 games. The defenseman later coached Springfield (1946–1951) and compiled a 120-179-41 record (.413 pct). In 15 NHL seasons (1931–1946), he had 276 points, 187 assists, and 746 PIM in 645 games. Seibert skated for two Stanley Cup–winning teams. (SHHOF.)

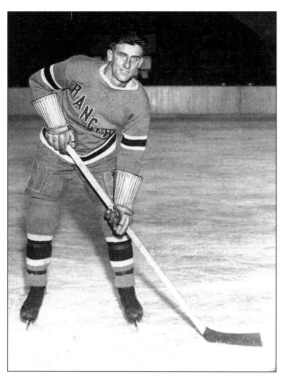

CECIL DILLON. In his three seasons with the Indians (1928–1931), he had 63 points and 31 assists in 86 games. Dillon went on to a 10-year NHL career (1930–1940) with the Rangers and Detroit, collecting 298 points and 167 goals in 453 games. The right winger won a Fontaine Cup with Springfield in 1930–1931 and a Stanley Cup with the Rangers in 1932–1933.

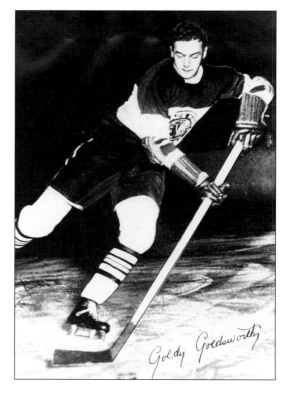

LEROY GOLDSWORTHY. The right winger played with Springfield during the franchise's first three seasons (1926–1929), winning Fontaine Cups with the team in 1926–1927 and 1927–1928. He had 32 points, 19 goals, and 76 PIM in 108 games with the Indians. Goldsworthy went on to a 10-year NHL career (1928–1931, 1932–1939) and collected 123 points and 66 goals in 336 games. He skated for Stanley Cup-winning Chicago in 1933–1934.

OTT HELLER. Heller began his professional career in Springfield, playing from 1929 to 1932 and compiling 53 points, 29 goals, and 147 PIM in 85 games. The defenseman went on to a 15-year NHL career with the Rangers (1931–1946) and was a member of two Stanley Cup–winning teams (1932–1933 and 1939–1940). He had 231 goals, 176 assists, and 465 PIM with the Rangers (NHL). Heller skated for Springfield's 1930–1931 championship team.

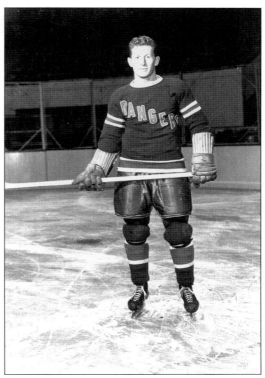

ALFIE MOORE. Moore was in net for Springfield in five seasons (1930–1933, 1935–1936, 1940–1941) and had a 2.53 GAA and a 44-23-10 record in 84 games. Moore helped the Indians win the 1930–1931 Fontaine Cup with a league-leading 29-2-2 record and a 2.42 GAA in 40 games. The goaltender spent four seasons in the NHL (1936–1940) and compiled a 3.77 GAA and a 7-14-0 record in 21 games.

13

BENNY GRANT. In his five years between the pipes for the Indians (1935–1940), Grant had a 2.95 GAA, a 77-99-32 record, and 21 shutouts in 209 games. The netminder appeared in six NHL seasons (between 1928 and 1944) with Toronto, the New York Americans, and Boston, earning a 3.75 GAA and a 17-26-4 record in 50 games. He was in net for five games with the 1931–1932 Stanley Cup-winning Maple Leafs.

GORD PETTINGER. Pettinger played on four Stanley Cup-winning teams—the Rangers (1932–1933), Detroit (1935–1936 and 1936–1937), and Boston (1938–1939). In eight NHL seasons (1932–1940), he had 116 points and 42 goals in 292 games. In his only season in Springfield (1932–1933), the center had 12 points and seven goals in 13 games.

JOHN "LITTLE NAPOLEON" ROACH. A veteran of 14 NHL seasons (1921–1935), Roach had a 2.46 GAA and a 219-204-68 record in 492 games. He won a Stanley Cup with Toronto in 1921–1922. The goaltender won his only game with Springfield in 1931–1932 with a 1.00 GAA.

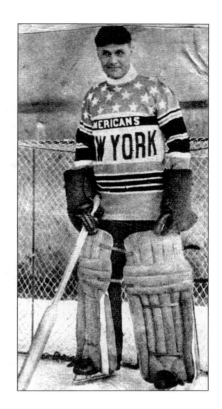

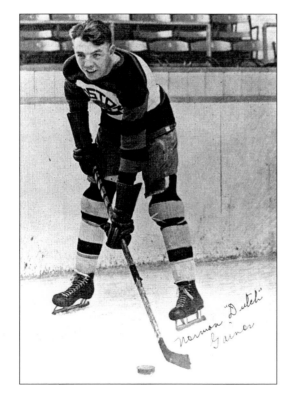

NORM "DUTCH" GAINOR. Gainor had 12 points and seven goals in 13 games with the Indians in 1932–1933. The center spent seven seasons in the NHL (1927–1933, 1934–1935) and garnered 107 points and 51 goals in 246 games. He won two Stanley Cups—with Boston in 1928–1929 and the Maroons in 1934–1935.

1928–1929 Springfield Program. The Springfield Indians were the first minor professional hockey team in North America to win two consecutive playoff championships (1926–1927 and 1927–1928). In 1928–1929, the club did not win a third straight championship, but four decades later would become the only AHL club to win three consecutive playoff championships, from 1959–1960 to 1961–1962.

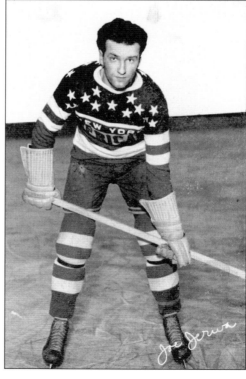

Joe Jerwa. Jerwa was a member of six playoff championship teams: three Fontaine Cups (with Springfield in 1930–1931 and Boston in 1932–1933 and 1934–1935), two Pacific Coast Hockey League (PCHL) championships (with Vancouver in 1928–1929 and 1929–1930), and one Calder Cup (with Cleveland in 1940–1941). In Springfield in 1930–1931, the defenseman had eight points and 26 PIM in nine games. In seven NHL seasons (between 1930 and 1939), he had 87 points and 309 PIM in 234 games.

RUSS BLINCO. Blinco had four points and two goals in 13 games with the Indians (1932–1933). The center went on to play in six NHL seasons (1933–1939) with the Maroons and Chicago and garnered 125 points and 59 goals in 268 games. He also won a Stanley Cup with the Maroons in 1934–1935.

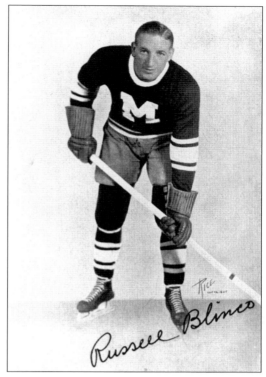

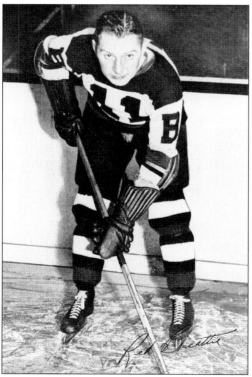

JOHN "RED" BEATTIE. In 1930–1931, Beattie had 14 points and eight goals in seven games with Springfield's Fontaine Cup-winning team. He continued on to play nine seasons in the NHL (1930–1939) with Boston, Detroit, and the Americans, and had 147 points, 85 assists, and 137 PIM in 334 games. The left winger won two PCHL championships with Vancouver (1928–1929 and 1929–1930).

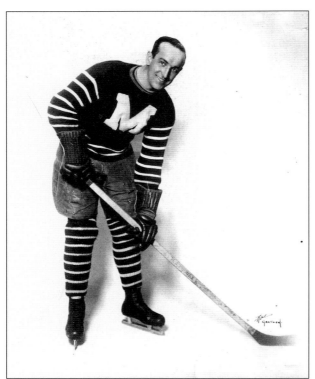

GEORGES "BUCK" BOUCHER. Elected to the Hockey Hall of Fame in 1960, Boucher coached the Indians during the last CAHL campaign (1935–1936) and during the first two IAHL seasons (1936–1938), compiling a 53-69-22 record (.444 pct). During his NHL career from 1917 to 1932 and 1933–1934, he had 204 points and 117 goals in 449 games. Boucher won four Stanley Cups with Ottawa (1920, 1921, 1923, and 1927).

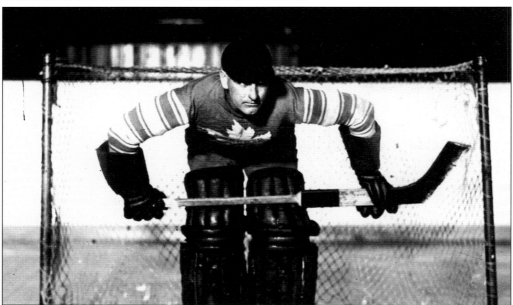

LORNE CHABOT. The goaltender appeared in only one game for Springfield in 1926–1927 and won the contest with a 2.00 GAA. Chabot played 11 years in the NHL (1926–1937) with six teams and had a 2.04 GAA, a 201-148-62 record, and 73 shutouts in 411 games. He won the NHL's Vezina Trophy for Outstanding Goaltender in 1934–1935 and won two Stanley Cups—with the Rangers in 1927–1928 and Toronto in 1931–1932.

Leo Bourgeault. Bourgeault had a stint with Springfield during its last season in the CAHL (1935–1936), garnering one point (goal) in two games. In eight NHL seasons (1926–1931, 1932–1935) with Toronto, the Rangers, Ottawa, and the Canadiens, he accumulated 269 PIM, 44 points, and 24 goals in 307 games. The defenseman won a Stanley Cup with the Rangers in 1927–1928.

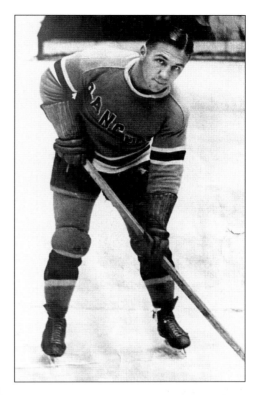

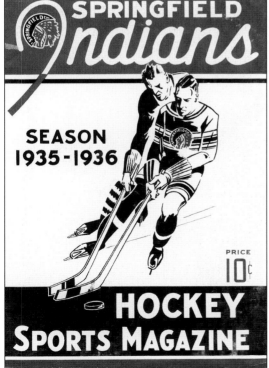

SPRINGFIELD *Indians*

SEASON 1935-1936

PRICE 10¢

HOCKEY SPORTS MAGAZINE

1935–1936 Springfield Program. In 1935–1936, the second Indians CAHL franchise was born when the Quebec Castors (CAHL members since 1932–1933) relocated to Springfield. The Indians were affiliated with Montreal (NHL). Canadiens' (NHL) farmhands included Max Bennett, Leo Bourgeault, Irv Frew, Gaston Leroux, and Paul Raymond. The original CAHL Quebec Castors (1926–1928) relocated to Newark (Bulldogs) in 1928–1929 and only lasted one season before the franchise folded.

HARRY "YIP" FOSTER. Yip won two Fontaine Cups (with Springfield 1927–1928 and Boston 1932–1933), a Teddy Oke Trophy (with Detroit [IHL] 1935–1936), and a Calder Cup (with Cleveland [IAHL] in 1938–1939). In Springfield from 1927 to 1929, the defenseman had 123 PIM, eight points, and six goals in 75 games. Foster played four NHL seasons, between 1929 and 1935, garnering five points and 32 PIM in 83 games.

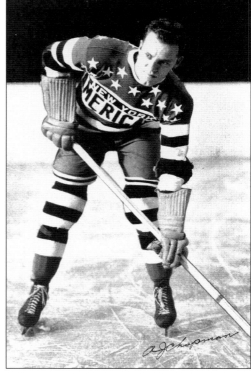

ART CHAPMAN. Chapman had 19 points and 14 goals in 39 games with Springfield's 1927–1928 championship team. Skating in 12 NHL seasons from 1930 to 1942 with Boston and the Americans, the center registered 238 points, 176 assists, and 140 PIM in 438 games. He also won a Fontaine Cup with Providence (1929–1930) and won two Calder Cups (AHL) in Buffalo (as a player and coach in 1942–1943 and as a coach in 1943–1944).

TWO

The Early American Hockey League Years

In 1936–1937, the CAHL and the International Hockey League (IHL, known as the CPHL from 1926–1929) combined to form the International-American Hockey League (IAHL). The IAHL would become known as the American Hockey League (AHL) in 1940–1941. The Indians, coached by Hall-of-Famer Georges Boucher, finished in second place in their division (22-17-9). Springfield made it past the first round of the playoffs versus Providence (two games to one), but lost in the semifinals against Philadelphia (two games to none). The following season, the club missed the playoffs with a 10-30-8 record and a last place finish.

In 1938–1939, the team again had a losing record (16-29-9) but this time made the playoffs. They lost in the first round against Cleveland (two games to one). Lionel Hitchman was the new coach, but was replaced mid-season by Johnny Mitchell (who would coach the team through 1941–1942). Defenseman Jimmy Orlando was an AHL second team all-star. On January 23, 1939, Indians' owner J. Lucien Garneau, who was more of a sportsman than a businessman, turned the operation of the franchise over to the IAHL because of financial reasons. As part of the IAHL's agreement to take over the Indians, Garneau had until June 1, 1939, to make final reorganization or sale plans to satisfy creditors and the league. Garneau informed the AHL that he intended to sell the club to Shore before his deadline. After four months of negotiation with Garneau and a satisfactory arrangement with his Boston club (NHL), Eddie Shore's purchase of the Indians was officially ratified by the IAHL on July 11, 1939.

Shore acted as player and owner in 1939–1940, while playing games in the NHL, and Springfield improved to .500 (24-24-6) and made the playoffs (they lost in the opening round to Pittsburgh [two games to one]). Max Kaminsky (center) was named a second team AHL all-star. The Indians steadily improved under Shore, who continued to play for the AHL squad and set up an affiliation with the Americans (NHL) from 1940 to 1942, with a winning record in 1940–1941 (26-21-9) and a division title in 1941–1942 (31-20-5). First team AHL all-star Pete Kelly (left wing) led the league in scoring with 78 points in 1941–1942. Frank Beisler (defense) was also named a first team AHL all-star that season, while Fred Thurier (center) was named

to the second team. Thurier was selected to the first team in 1940–1941. Shore was forced to suspend his franchise before the 1942–1943 season, when he lost access to the Eastern States Coliseum. The facilities were taken over by the U.S. Army Quartermaster Corps following the outbreak of World War II.

In 1946–1947, Shore returned to Springfield. The locals were coached by former Indians player Earl Seibert (who would pilot the team through 1950–1951). Springfield finished second in its division (24-29-11) but was eliminated in the first playoff round against Buffalo (two games to none). Over the next four seasons (1947–1948 to 1950–1951), the Indians did not have a regular season winning record and did not get past the first round of the playoffs. Center Eldie Kobussen (second team in 1947–1948) and left wing Bill Gooden (second team in 1950–1951) were the club's only AHL all-stars during that time.

Shore was persuaded by the AHL Board of Governors, who wanted to expand the league, to relocate the Indians to Syracuse, New York, to a brand-new state-of-the-art facility. After three seasons as the Syracuse Warriors (1951–1954), the franchise was revoked by the AHL because it could not obtain enough home dates to complete a home-and-home season schedule. Shore, who incurred losses of considerably more than $100,000 in Syracuse, returned to Springfield as coach of the team in 1954–1955 and piloted the franchise to its first winning season (32-29-3) since 1941–1942. In the playoffs, the Indians lost to Pittsburgh in the first round (three games to one). Jimmy Anderson won the Red Garrett Memorial Award for Outstanding Rookie, and Ross Lowe (center) and Gordon Tottle (defense) were named AHL first team all-stars, while Don Simmons (goalie) made the second team. Over the next two seasons, the tribe suffered last place finishes, with Bill Mitchell (1955–1956) and Hall-of-Famer George "Punch" Imlach (1956–1957) as coach.

In 1957–1958, Springfield formed an affiliation with the Boston Bruins, which lasted only one season. The Bruins sent Cal Gardner as player and coach. The team still could not crack the .500 regular season mark (29-33-8) but made the Calder Cup finals for the first time. Springfield won its first playoff series since 1936–1937, defeating Cleveland in seven games. In the finals, Hershey beat the locals four games to two. Gerry Ehman (first team, left wing) and Gardner (second team, center) were named to the AHL all-star team.

The tribe missed the playoffs in 1958–1959 with a 30-38-2 record under coach Glen Sonmor. Harry Pidhirny (center) and Ken Schinkel (right wing) made the AHL second all-star team.

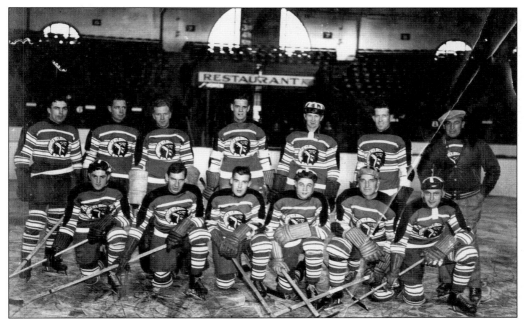

SPRINGFIELD INDIANS INAUGURAL AHL TEAM, 1936–1937. Pictured here, from left to right, are the following: (first row) Paul Raymond, Ted Saunders, Frank Daley, Irv Frew, Frank Jerwa, and Jacques Toupin; (second row) Cliff McBride, Adelard LaFrance, Benny Grant, Gene Carrigan, Joe McGoldrick, Tom Filmore, and coach Georges Boucher.

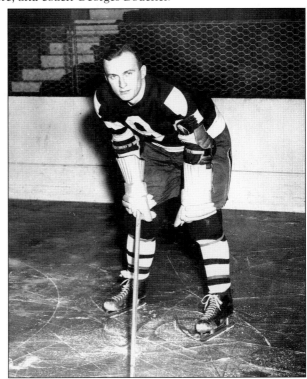

MAX BENNETT. The right winger played two seasons for Springfield (1935–1937) and had 15 points, 9 assists, and 27 PIM in 45 games. Bennett was a member of two Calder Cup championship teams with Buffalo (1942–1943 and 1943–1944). He also had a stint in the NHL with the Canadiens in 1935–1936.

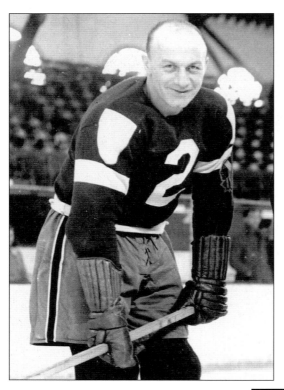

EDDIE SHORE, TWO TEAMS AT ONCE.
During the 1939–1940 season, Shore played in the NHL (Bruins, Americans) and with the Indians. Boston arranged for him to play home games only but soon traded him to the New York Americans, where his NHL career ended that season. According to one story, the legendary defenseman played in 19 games in 23 days in both the AHL and NHL in 1939–1940.

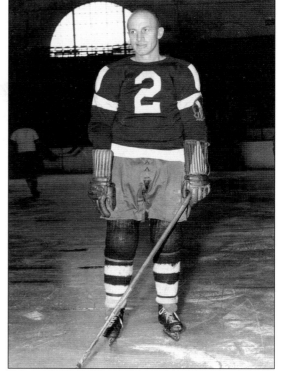

EDDIE SHORE. Shore had 49 points, 39 assists, and 145 PIM in 106 games during his three seasons skating with Springfield (1939–1942). The defenseman, good friends with Americans (NHL) coach Red Dutton, set up an affiliation between the Indians and Americans for two seasons (1940–1942).

PHIL McATEE. This netminder was between the pipes in five seasons (1941–1942, 1946–1947, 1948–1951) with the Indians and had a 3.72 GAA in 138 games. McAtee also played in the AHL with Hershey (1940–1941) and Buffalo (1951–1953) and spent time in the PCHL, QHL, and the United States Hockey League (USHL).

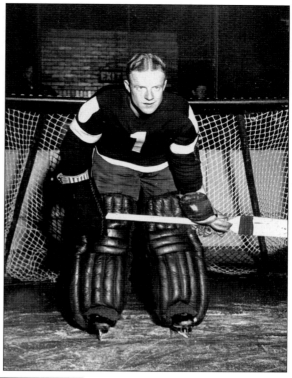

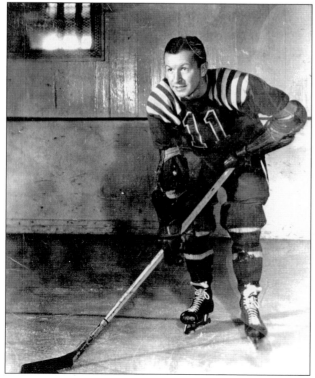

FRED THURIER. Thurier played on four Calder Cup-winning teams with Buffalo (1942–1943 and 1943–1944) and Cleveland (1947–1948 and 1950–1951). He also spent five seasons in Springfield (1937–1942), registering 202 points, 104 assists, and 108 PIM in 199 games. The center played three NHL seasons (1940–1942, 1944–1945) with the Americans and Rangers, scoring 25 goals and 52 points in 80 games. (SHHOF.)

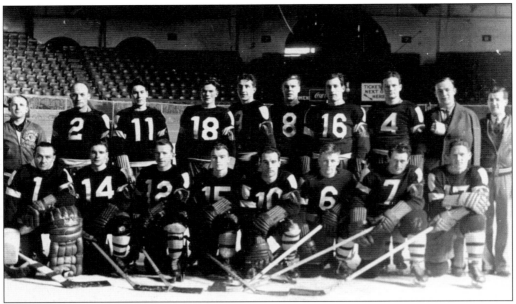

1941–1942 SPRINGFIELD INDIANS. Shown here, from left to right, are the following: (first row) Earl Robertson, John O'Flaherty, Fred Hunt, Doug Lewis, Bill Summerhill, Bob Dill, Max Kaminsky, and Pete Kelly; (second row) coach Johnny Mitchell, Eddie Shore, Jim Peters Sr., Scotty McPherson, Bus Wycherley, Nick Knott, Art Simmons, Rhys Thompson, Frank Beisler, and Harvey Stone.

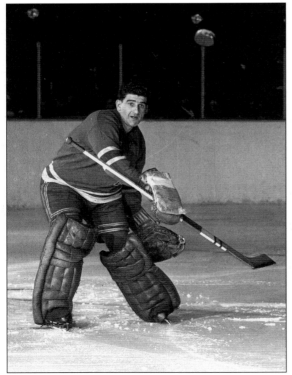

CHUCK RAYNER. Inducted into the Hockey Hall of Fame in 1973, Rayner played two seasons with the Indians (1940–1942) and had a 2.33 GAA, an 18-13-6 record, and six shutouts in 38 games. The 10-year NHL veteran had a 3.05 GAA and a 138-208-77 record in 424 games and won the Hart Trophy (NHL MVP) in 1949–1950. The goaltender was assigned to Springfield by the Americans (NHL).

GORDON TOTTLE. Tottle played the eighth most games (433) in Indians/Kings history. The defenseman had 151 points and 121 assists during his seven seasons with Springfield (1947–1951, 1954–1957). He also played with the QHL Indians (1953–1954) and had 8 points and 28 PIM in 21 games. (SHHOF.)

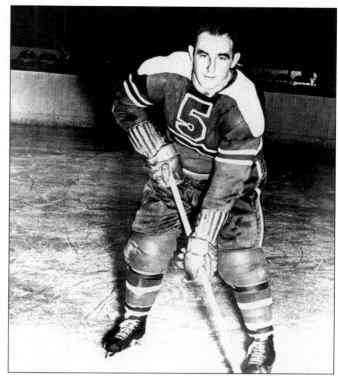

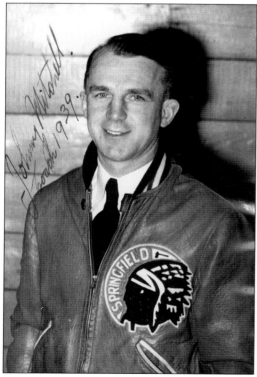

JOHNNY MITCHELL. Replacing Lionel Hitchman in 1938–1339, Mitchell coached Springfield until 1941–1942. In his three full seasons piloting the team (1939–1942), Mitchell had an 81-65-20 (.548 pct) record. He guided the Indians to their first AHL division title in 1941–1942. The coach was also behind the bench in the AHL with Providence (1943–1944) and St. Louis (1950–1951).

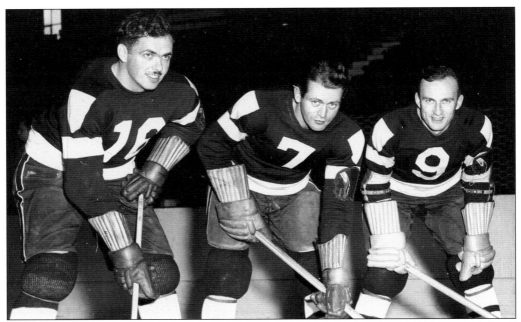

MAX KAMINSKY BETWEEN GENE CARRIGAN (LEFT) AND MAX BENNETT. Kaminsky played five seasons as center for Springfield (1937–1942) and garnered 131 points and 52 goals in 223 games. He is a veteran of four NHL seasons (1933–1937) with Ottawa, Boston, St. Louis, and the Maroons. The center had 56 points and 22 goals in 130 NHL games.

BILL GOODEN. Gooden is fifth all-time in goals (144) and eighth all-time in points (308) in Indians/Kings history. In his five seasons with the tribe (1946–1951), the left winger also had 164 assists in 320 games. Prior to coming to Springfield, he played two years in the NHL with the Rangers (1942–1944) and had 20 points and 11 assists in 53 games. (SHHOF.)

KEITH "BINGO" ALLEN. Allen was inducted into the Hockey Hall of Fame as a builder in 1992. In his five years with Springfield (1946–1951), the defenseman had 117 points and 99 assists in 319 games. Bingo later coached in the AHL and has the distinction of being the only coach ever to lead a team to a Calder Cup championship during the franchise's first two seasons of existence (Maine 1977–1978 and 1978–1979). (SHHOF.)

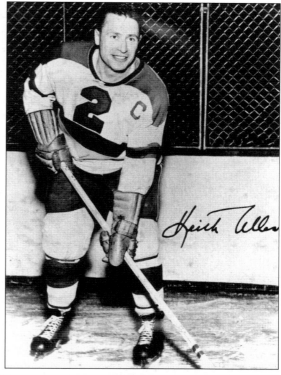

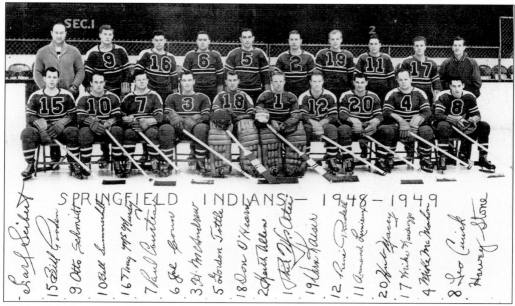

1948–1949 SPRINGFIELD INDIANS. Pictured here, from left to right, are the following: (first row) Bill Gooden, Bill Summerhill, Paul Courteau, Hazen McAndrew, Don O'Hearn, Phil McAtee, Rene Trudell, Hub Macey, Mike McMahon, and Leo Curik; (second row) coach Earl Seibert, Otto Schmidt, Doug McMurdy, Joe Conn, Gordon Tottle, Keith Allen, Vern Kaiser, Armand Lemieux, Mike Narduzzi, and Harvey Stone.

BILL WHITE. White skated for five seasons with Springfield (1962–1967), registering 175 points, 143 assists, and 290 PIM in 349 games. A veteran of nine NHL seasons (1967–1976) with Los Angeles and Chicago, he collected 265 points, 215 assists, and 495 PIM in 604 games. The defenseman coached Chicago (NHL) in 1976–1977. (SHHOF.)

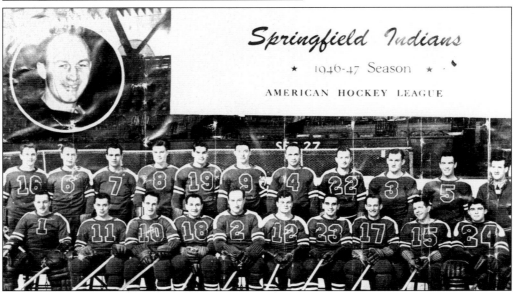

1946–1947 SPRINGFIELD INDIANS. Team members, shown here from left to right, are as follows: (first row) Floyd Perras, Bill Cupolo, Bill Summerhill, Joe Benoit, coach Earl Seibert, Paul Courteau, Ray Voll, William Woodward, Bill Gooden, and Ralph Tattam; (second row) Eldy Kobussen, Keith Allen, John Quilty, Ross Johnstone, Bob Dawes, Arthur Herschenratter, Alex Motter, Harry Frost, Sandy Milne, Hazen McAndrew, and Harvey Stone. Eddie Shore appears in the upper left insert.

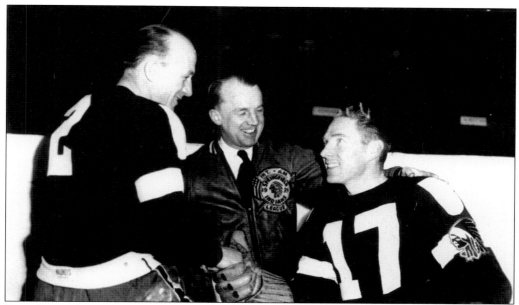

PETE KELLY (RIGHT) WITH EDDIE SHORE (LEFT) AND COACH JOHNNY MITCHELL. Kelly played two seasons at right wing for Springfield (1940–1942) and had 97 points and 39 goals in 65 games. Kelly was assigned to Springfield by the Americans (NHL). In seven NHL seasons (1934–1939, 1940–1942), he collected 59 points and 21 goals in 177 games. He won two Stanley Cups with Detroit (1935–1936 and 1936–1937).

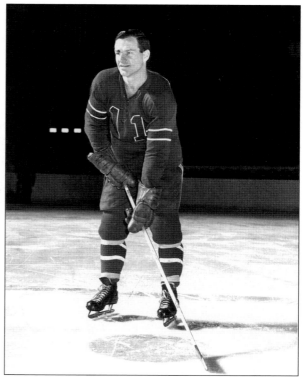

CAL GARDNER. Gardner was a player and the coach for the Indians during the 1957–1958 season, leading the club to its first Calder Cup finals appearance with a 29-33-8 record (.471 pct). Gardner had 81 points and 57 assists in 69 games for Springfield that season. The 12-year NHL veteran (1945–1957) had 392 points, 238 assists, and 517 PIM in 696 games. The center won two Stanley Cups with Toronto (1948–1949 and 1950–1951).

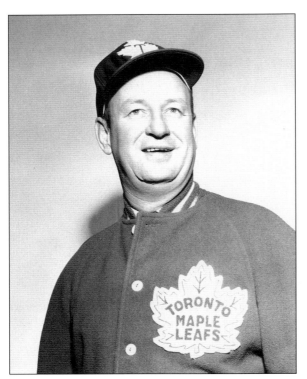

GEORGE "PUNCH" IMLACH. Imlach coached in 14 NHL seasons (1958–1969, 1970–1972, 1979–1980) with Toronto and Buffalo. He won four Stanley Cups with the Maple Leafs (1961–1962 to 1963–1964 and 1966–1967) and compiled a 402-337-150 (.537 pct) regular season record. Punch piloted the Indians to a 19-41-4 (.328 pct) record and a last-place finish during the 1956–1957 season.

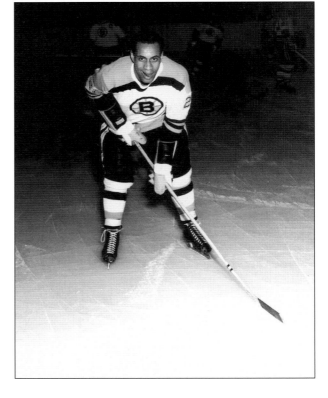

WILLIE O'REE. O'Ree became the first black player in NHL history when he joined Boston for two games on January 18 and 19, 1958. He played 43 games for the Bruins (NHL) in 1960–1961 and had 14 points and 10 assists. The right winger appeared in six games for Springfield in 1957–1958. He won an O'Connell Trophy with Quebec (QHL) in 1956–1957.

LARRY HILLMAN. The veteran of 19 NHL seasons (1954–1973) spent part of the 1962–1963 season in Springfield, achieving 28 points, 23 assists, and 56 PIM in 65 games with the Indians. The defenseman skated for six Stanley Cup–winning teams (Detroit 1954–1955; Toronto 1961–1962, 1962–1963, 1963–1964, and 1966–1967; and Montreal 1968–1969) and three Calder Cup-winning teams (Rochester 1964–1965, 1965–1966, and 1967–1968).

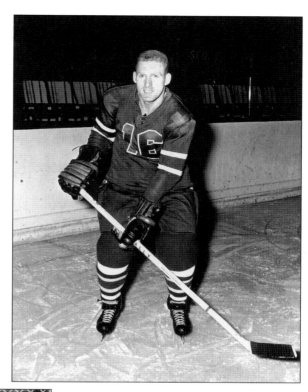

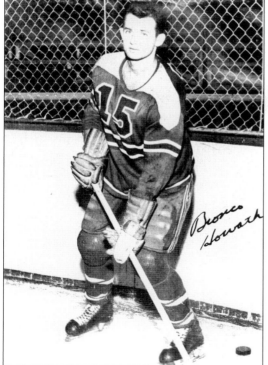

JOSEPH "BRONCO" HORVATH. Horvath spent one season with the AHL Indians (1950–1951) and had 38 points, 26 assists, and 37 PIM in 43 games. He played nine seasons in the NHL (1955–1963, 1967–1968), registering 141 goals and 326 points. The center won three Calder Cups with Rochester (1964–1965, 1965–1966, and 1967–1968). Bronco also skated for the QHL Indians (1953–1954).

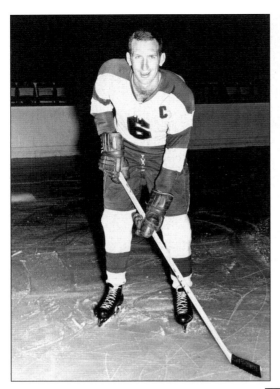

DALE ROLFE. Rolfe played five seasons with Springfield (1963–1968) and had 140 points, 108 assists, and 361 PIM in 284 games. In his nine years in the NHL (1959–1960, 1967–1975), he garnered 150 points, 125 assists, and 556 PIM in 509 games. The defenseman won a Patrick Cup in the Western Hockey League (WHL) with Portland (1960–1961). (SHHOF.)

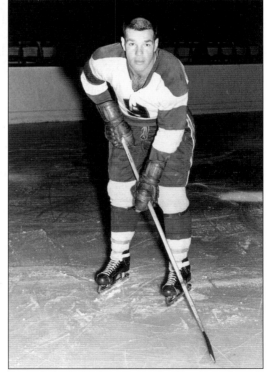

ROGER COTE. Cote played seven seasons with the Indians/Kings (1962–1968, 1969–1970), achieving 161 points, 91 assists, and 610 PIM in 389 games. The defenseman was a veteran of three seasons in the WHA (1972–1975) with Alberta/Edmonton and Indianapolis. He had 17 points and 104 PIM in 155 WHA games.

GARY BERGMAN. The defenseman played one season for Springfield (1963–1964) and had 37 points and 106 PIM in 60 games. He then had a 12-year NHL career (1964–1976) with Detroit, Minnesota, and Kansas City, accumulating 1,249 PIM, 367 points, and 299 assists in 838 games.

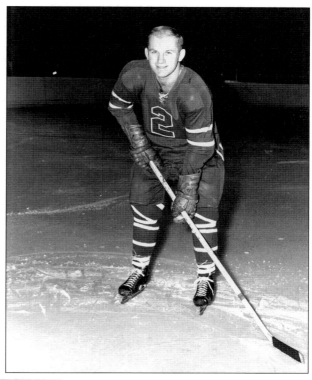

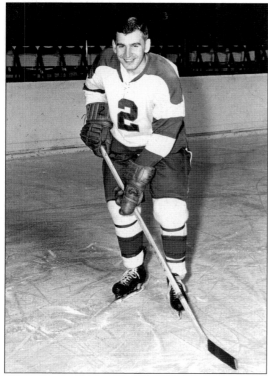

BARCLAY PLAGER. In his three years with the Indians (1964–1967), Plager had 67 points, 48 assists, and 179 PIM in 133 games. In his 10-year NHL career (1967–1977), he had 231 points and 1,115 PIM in 614 games. The defenseman won one Foley Trophy (EPHL) with Hull-Ottawa (1960–1961) and two Adams Cups (Central [Professional] Hockey League [CPHL/CHL]) with Omaha (1963–1964) and Kansas City (1976–1977).

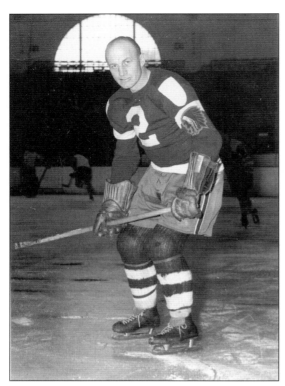

EDDIE SHORE, ONE OF THE FIRST HALL OF FAMERS. Shore was a member of the second class of inductees in the Hockey Hall of Fame in 1947 and the first Indians player to achieve that honor.

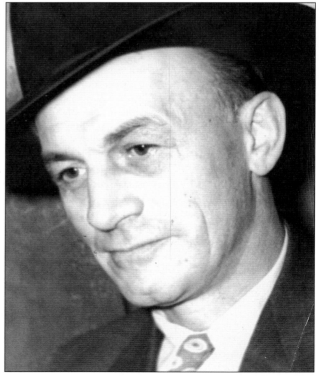

OWNER EDDIE SHORE. Besides owning the Indians, Shore also owned and/or operated the Buffalo Bisons (AHL), Fort Worth Rangers (USHL), New Haven Eagles (AHL), Oakland Oaks (PCHL), San Diego Skyhawks (PCHL), Syracuse Warriors (AHL), and another version of the Springfield Indians (EAHL/QHL). At one time, Shore had 80 players under contract.

THREE

Calder Cup Hat Trick

The Springfield Indians are the only team in the history of the American Hockey League to win three consecutive Calder Cups, in 1959–1960, 1960–1961, and 1961–1962. The club had the best AHL regular season record during all three championship years. There were 12 players who were members of all three Calder Cup teams. Pat Egan, former Springfield player, was the team's coach and Hall-of-Famer Jack Butterfield was the general manager during the championship reign. The Indians had a working agreement with the New York Rangers (NHL) during all three seasons. Hall-of-Famer Lorne "Gump" Worsley, Parker MacDonald, Marcel Paille, Noel Price, Eddie Shack, and Art Stratton were among the players assigned to Springfield by the Rangers.

In 1959–1960, the Indians captured their first AHL regular season crown (43-23-6). There were five AHL all-stars on the squad: (first team) Bill Sweeney (center); (second team) Floyd Smith (right wing), MacDonald (left wing), Bob McCord (defense), and Paille (goalie). Springfield had three of the AHL's top 10 scorers: Sweeney (second, 96 points), Floyd Smith (third, 82 points), and Bruce Cline (ninth, 75 points). Paille was fifth in league goaltending (3.21 GAA). In the semifinals (opening round) of the Calder Cup playoffs, the Indians beat the Providence Reds four games to one. Springfield went on to win its first Calder Cup ever against the Rochester Americans in five games.

The 1960–1961 Indians won the AHL regular season title by an amazing 23 points over the next best club. It was the largest margin that an overall point champion ever had in league history—a record that would stand until the 1992–1993 season. En route to its second Calder Cup championship, Springfield became only the second team in Calder Cup playoff history to have a perfect postseason record (8-0). The 49-22-1 club placed five scorers in the AHL's top 10 in points: Sweeney (first, 108), Cline (third, 92), Brian Kilrea (fourth, 87), Bill McCreary (fifth, 87), and Jimmy Anderson (seventh, 81). Paille led the league in goaltending with a 2.81 GAA and received the AHL's Harry "Hap" Holmes Award. McCord won the AHL's Eddie Shore Award for Outstanding Defenseman. The club again boasted five AHL all-stars on the team: (first team) Cline (right wing), McCord (defense), and Paille (goalie); (second team) Sweeney (center) and

Anderson (left wing). The Indians' perfect 8-0 playoff sweep was against the Cleveland Barons in the semifinals and the Hershey Bears in the finals.

The AHL expanded in 1961–1962 and had a two-division alignment, Springfield being in the Eastern Division. The Calder Cup playoff format changed as well. The two division winners would play each other in an opening round match-up with the series winner given a berth in the finals. Springfield, who won the Eastern Division (45-22-3), faced Western Division champion Cleveland. The Indians took the series in six games. For its unequaled third straight Calder Cup championship, Springfield beat the Buffalo Bisons four games to one. Paille (2.56 GAA) once again received the AHL's Harry "Hap" Holmes Award, while Kent Douglas won the AHL's Eddie Shore Award. For the third consecutive year, there were five AHL all-stars on the squad: (first team) AHL leading scorer (101 points) Sweeney (center), Douglas (defense), and Paille (goalie); (second team) Floyd Smith (right wing) and McCord (defense).

The Springfield Indians' achievement of three straight Calder Cup championships remains unparalleled and is perhaps the most difficult team record to match in the AHL. Only four teams since—including the 1989–1990 and 1990–1991 Springfield Indians—have won back-to-back Calder Cups. The record may never be broken or even equaled.

Over the next five seasons, the Indians won only one playoff series (1965–1966) and posted just two winning records: 1962–1963 (33-31-8) and 1966–1967 (32-31-9). Egan continued to pilot the team through 1964–1965. Following the "Egan Era," Springfield had four coaches in two seasons: Al Murray and Jack Butterfield in 1965–1966 and Harry Pidhirny and Eddie Shore Jr. in 1966–1967. AHL all-star players included Cline (right wing) and McCord (defense) in 1962–1963 (both second team), Anderson (left wing) in 1963–1964 (second team), and Dale Rolfe (defense) in 1966–1967 (first team). The close of the 1966–1967 season marked the end of an era in Springfield hockey.

BILL SWEENEY. Sweeney ranks second all-time in points (652) and assists (420), third all-time in goals (232), and fourth all-time in games (545) in Indians/Kings history. He played nine seasons for the Indians/Kings (1959–1968), a member of the three straight Calder Cup-winning teams. The center is eighth all-time in assists (510) and tenth all-time in points (804) in AHL history. (SHHOF.)

MARCEL PAILLE. Paille was the leading goaltender during Springfield's Calder Cup three-year reign. He had a 107-54-8 record, a 2.86 GAA, and 12 shutouts in 169 games with the Indians. In 1960–1961, he led the AHL in GAA (2.81), wins (46), and shutouts (8). The goaltender played seven NHL seasons (1957–1963, 1964–1965) and had a 32-52-22 record and a 3.42 GAA in 107 games with the Rangers. (SHHOF.)

BOB MCCORD. McCord is fifth all-time in games (488) and sixth all-time in assists (193) in Indians/Kings history. The defenseman also had 256 points and 63 goals during his nine-year career in Springfield (1954–1963). The seven-year NHL veteran (1963–1969, 1972–1973) won the AHL's Eddie Shore Award twice (1960–1961 and 1966–1967) and played for four Calder Cup-winning teams (Springfield 1960, 1961, 1962 and Pittsburgh 1967). (SHHOF.)

HARRY PIDHIRNY. Pidhirny is second all-time in goals (235) and games (599) and fourth all-time in points (546) and assists (311) in team history. He played nine years with Springfield (1949–1951, 1954–1961) and was a member of two Calder Cup teams (1960 and 1961). The center also ranks high among the all-time leaders in AHL history: third in games (1,071), sixth in goals (376), and seventh in points (829). (SHHOF.)

HARRY PIDHIRNY

PAT EGAN. Egan coached the tribe from 1959 to 1965, guiding the club to a 222-181-27 (.548 pct) regular season record and an AHL record of three consecutive Calder Cups (1960, 1961, and 1962). The defenseman also played one season with the Indians (1939–1940) and had 23 points, 12 goals, and 74 PIM in 47 games. The 11-year NHL veteran (1939–1942, 1943–1951) had 230 points and 776 PIM in 554 games. (SHHOF.)

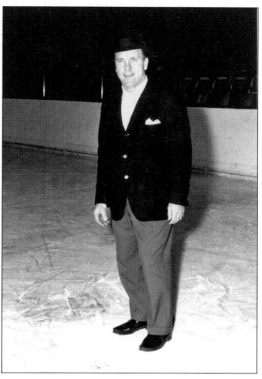

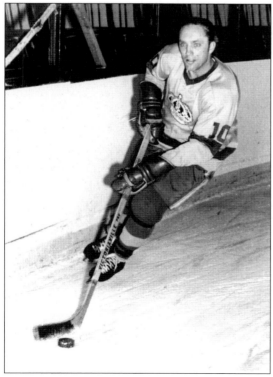

JIMMY ANDERSON. Anderson is the Indians/Kings all-time leader in points (816), goals (425), games (929), and seasons (16) and is third all-time in assists (391). He played with Springfield from 1954 to 1970, winning three Calder Cups. The left winger is fifth all-time in goals (426), eighth all-time in points (821), and 10th all-time in games (943) in AHL history. (SHHOF.)

KENT DOUGLAS. In his five years with the Indians (1955–1956, 1958–1962), Douglas had 132 points, 91 assists, and 478 PIM in 203 games. The defenseman was a member of three Springfield Calder Cup-winning teams (1960, 1961, and 1962). Douglas played seven seasons in the NHL (1962–1963, 1963–1969) with Toronto, Oakland, and Detroit. He was a member of three Stanley Cup–winning teams with Toronto (1963, 1964, and 1967).

FLOYD SMITH. Smith played five years with Springfield (1957–1962), winning three Calder Cups (1960, 1961, and 1962). The right winger ranks fifth all-time in points (337) and assists (196) and seventh all-time in goals (141) in Indians/Kings history. Smith spent 13 NHL seasons (between 1954 and 1972) with five different teams, accumulating 307 points and 129 goals in 616 NHL games. (SHHOF.)

GERRY FOLEY. Foley ranks seventh all-time in points (312) and games played (454), eighth all-time in assists (189), and ninth all-time in goals (123) in Indians/Kings history. The right winger played eight seasons for the Indians/Kings (1959–1961, 1962–1968) and was a member of two Calder Cup–winning teams (1960 and 1961). He spent four years in the NHL (between 1954 and 1969). (SHHOF.)

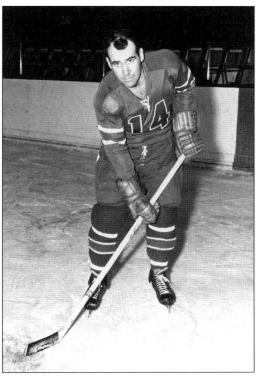

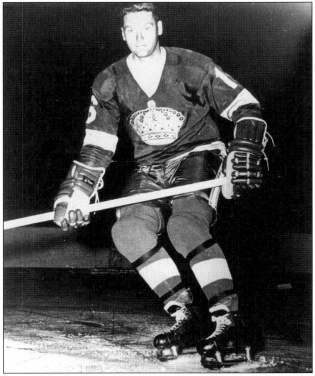

BRIAN KILREA. The Hall-of-Famer (inducted in 2003) ranks first all-time in assists (442), third all-time in points (611) and games (589), and fourth all-time in goals (169) in Indians/Kings history. A center, Kilrea played nine seasons with Springfield (1959–1968) and was a member of three Calder Cup–winning teams (1960, 1961, and 1962). He coached the Ottawa 67's (OHA/OHL) for 28 years (between 1974 and 2005). (SHHOF.)

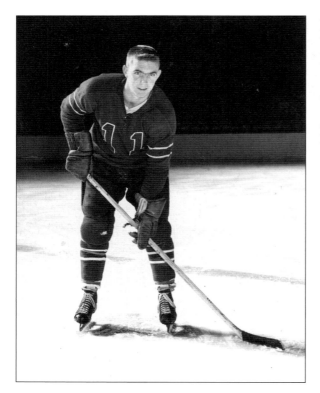

BILL MCCREARY SR. The left winger was a member of six championship teams, winning five Calder Cups (Providence 1955–1956, Hershey 1957–1958, Springfield 1960, 1961, and 1962) and one Adams Cup (Omaha 1963–1964). In his four seasons with the Indians (1958–1962), he had 261 points and 168 assists in 275 games. (SHHOF.)

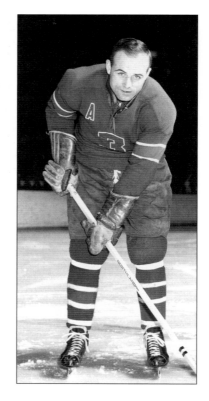

NOEL PRICE. Price was a member of five Calder Cup-winning teams: Springfield (1960, 1961, and 1962) and Nova Scotia (1972 and 1976). Price had 114 points, 93 assists, and 288 PIM in 230 games during five seasons with Springfield (1959–1962, 1969–1970, 1971–1972). The defenseman is a 14-year NHL veteran, playing between 1957 and 1976 with seven different clubs. He had 128 points and 333 PIM in 499 NHL games. (SHHOF.)

BRUCE CLINE. Cline is sixth all-time in points (332) and goals (142) and seventh all-time in assists (190) in Indians/Kings history. The right winger played four seasons with the Indians (1959–1963) and was a member of three Calder Cup teams (1960, 1961, and 1962). Cline ranks 11th all-time in goals (321) and 15th all-time in points (773) in AHL history. (SHHOF.)

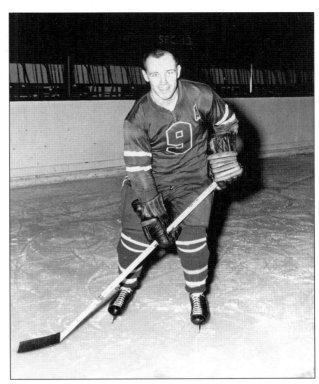

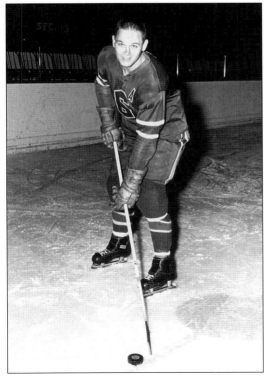

TED HARRIS. The five-time Stanley Cup winner with Montreal (1965, 1966, 1968, and 1969) and Philadelphia (1974–1975) played on three Springfield Calder Cup-winning teams (1960, 1961, and 1962). The defenseman also won a Calder Cup with Cleveland (1963–1964). In his six years with Springfield (1956–1957, 1958–1963), Harris had 114 points, 96 assists, and 505 PIM in 285 games.

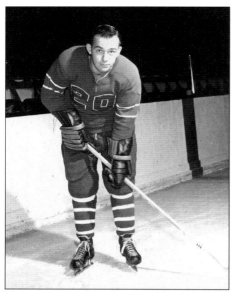

PARKER MACDONALD. MacDonald was a member of the 1959–1960 Calder Cup-winning team, collecting 73 points and 37 goals in 65 games. He spent 14 years in the NHL (between 1952 and 1969) with five different teams and had 323 points, 144 goals, and 253 PIM in 676 games. He also played on two Pittsburgh Calder Cup-winning teams (1954–1955 and 1966–1967).

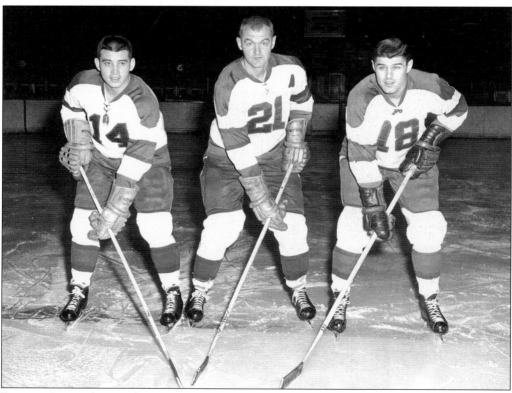

DENNIS OLSON (MIDDLE) WITH DAVE DUKE (LEFT) AND BOB KABEL. Olson ranks eighth all-time in goals (126), ninth all-time in points (307) and games (432), and 10th all-time in assists (181) in Indians/Kings history. In seven seasons with the team (1958–1965), he won three Calder Cups (1960, 1961, and 1962). Olson also set the Indians/Kings all-time record for consecutive games played (316). (SHHOF.)

GEORGE WOOD. Wood played eight seasons for Springfield (1960–1968) and had a 3.36 GAA in 216 games. He was a member of two Calder Cup-winning teams (1961 and 1962). The goalie also spent time with Rochester (AHL) in 1968–1969, Washington (EHL) in 1959–1960, San Francisco (WHL) in 1961–1962, and Des Moines (IHL) in 1968–1969.

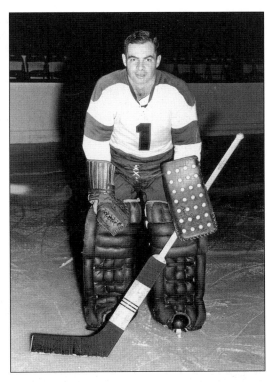

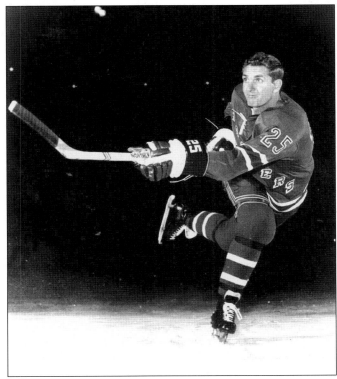

ORLAND KURTENBACH. The center played part of the 1959–1960 championship season with Springfield, garnering six points and 17 PIM in 14 games. Kurtenbach played in 13 NHL seasons (1960–1962, 1963–1974), totaling 332 points, 119 goals, and 628 PIM in 639 games. He played on three WHL playoff championship teams (Vancouver 1957–1958 and 1959–1960 and San Francisco 1962–1963).

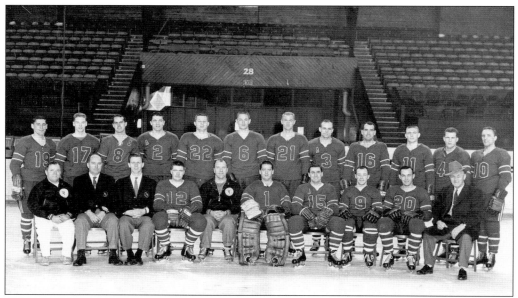

1959–1960 SPRINGFIELD INDIANS. Pictured here, from left to right, are the following: (first row) Wally Barlow (trainer), Jack Butterfield (general manager), Eddie Shore Jr. (vice president), Bill Sweeney, Pat Egan (coach), Marcel Paille, Floyd Smith, Bruce Cline, Parker MacDonald, and Eddie Shore (president); (second row) Jim Bartlett, Brian Kilrea, Harry Pidhirny, Bob McCord, Ian Cushenan, Ted Harris, Dennis Olson, Noel Price, Gerry Foley, Bill McCreary, Kent Douglas, and Jim Anderson.

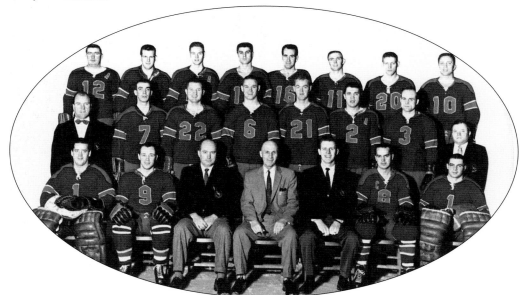

1960–1961 SPRINGFIELD INDIANS. Team members, from left to right, are as follows: (first row) Marcel Paille, Bruce Cline, Jack Butterfield, Eddie Shore, Eddie Shore Jr., Harry Pidhirny, and George Wood; (second row) Pat Egan, Jack Caffery, Ian Cushenan, Ted Harris, Dennis Olson, Bob McCord, Noel Price, and Wally Barlow; (third row) Bill Sweeney, Kent Douglas, Brian Kilrea, Bob Kabel, Gerry Foley, Bill McCreary, Ken Schinkel, and Jimmy Anderson.

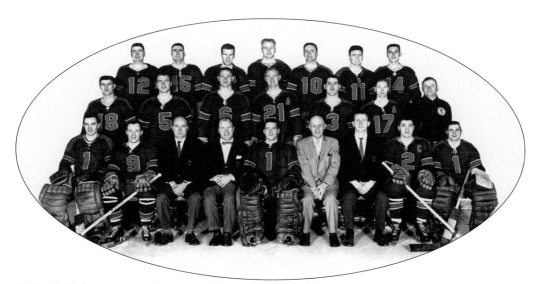

1961–1962 SPRINGFIELD INDIANS. Shown here, from left to right, are the following: (first row) Jacques Caron, Bruce Cline, Jack Butterfield, Pat Egan, Marcel Paille, Eddie Shore, Eddie Shore Jr., Bob McCord, and George Wood; (second row) Bob Kabel, Dave Amadio, Ted Harris, Dennis Olson, Pete Goegan, Brian Kilrea, and Wally Barlow; (third row) Bill Sweeney, Floyd Smith, Kent Douglas, Don Johns, Jimmy Anderson, Bill McCreary, and Dave Duke.

JACK BUTTERFIELD. Butterfield was inducted into the Hockey Hall of Fame in 1980 as a builder. He enters his 12th season as chairman of the Board of Governors of the AHL after serving 28 years (1966–1994) as the league's president. The AHL Indians' general manager for 10 years (1957–1967), he served in a number of other capacities since coming to the club permanently in 1949. (SHHOF.)

LORNE "GUMP" WORSLEY. Elected to the Hockey Hall of Fame in 1980, the goaltender played part of the 1959–1960 season with Springfield and had an 11-3-1 record, three shutouts, and a 2.20 GAA in 15 games. Gump had a 21-year NHL career (1952–1953, 1954–1974) that included a 2.88 GAA, 43 shutouts, four Stanley Cups (1965, 1966, 1968, and 1969) and a 335-352-150 record in 861 games.

JACQUES CARON. Caron was between the pipes in seven seasons for Springfield (1961–1968) and had a 3.51 GAA and a 94-108-22 record in 239 games. He played in the NHL for five years (1967–1969, 1971–1974), ending with a 3.29 GAA and a 24-29-11 record in 72 games. In his two WHA seasons (1975–1977), he had a 2.91 GAA and a 14-6-3 record in 26 games. (SHHOF.)

EDDIE SHACK. The left winger was a member of the Indians 1959–1960 Calder Cup-winning team. He had seven points, four assists, and 10 PIM in nine games with Springfield. In his 17-year NHL career (1958–1975) with six teams, he had 465 points, 239 goals, and 1,437 PIM in 1,047 games. Shack was a member of four Stanley Cup–winning teams with Toronto (1962, 1963, 1964, and 1967).

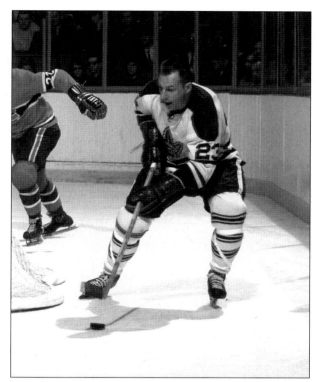

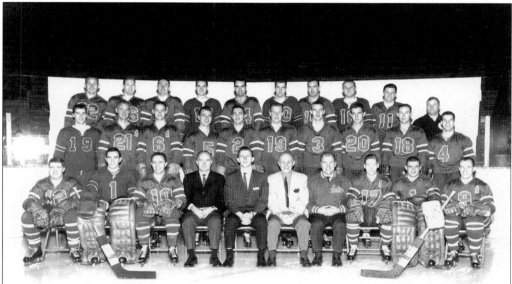

1962–1963 SPRINGFIELD INDIANS. Pictured here, from left to right, are the following: (first row) Bill Sweeney, Jacques Caron, Jimmy Anderson, Jack Butterfield, Eddie Shore Jr., Eddie Shore, Pat Egan, Brian Kilrea, George Wood, and Bruce Cline; (second row) unidentified, Dennis Olson, Ted Harris, Dave Amadio, Bob McCord, Dale Anderson, Bill White, Murray Davison, John Sleaver, and Roger Cote; (third row) John Chasczewski, Larry Hillman, Jim Wilcox, unidentified, Gerry Foley, Wayne Larkin, two unidentified players, Wally Boyer, and Wally Barlow.

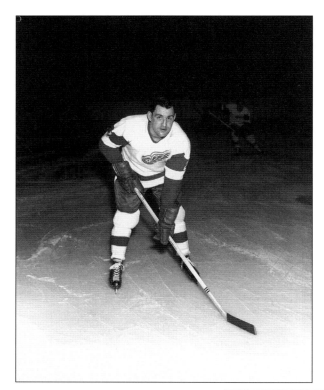

PETE GOEGAN. Goegan played briefly for the Indians' 1961–1962 Calder Cup-winning team and had one point and 12 PIM in seven games. Goegan was in the NHL for 11 seasons (1957–1968) with Detroit, the Rangers, and Minnesota and had 86 points, 67 assists, and 365 PIM in 383 games. The defenseman also won Calder Cups with Cleveland (1956–1957) and Pittsburgh (1966–1967).

DON "GRAPES" CHERRY. The *Hockey Night in Canada* personality played four seasons with the Indians (1957–1960, 1961–1962). The defenseman had 71 points, 53 assists, and 256 PIM in 192 games. Grapes skated on five Calder Cup–winning teams: two in Springfield (1960 and 1962) and three in Rochester (1965, 1966, and 1968). He coached in the NHL for six seasons with Boston (1974–1979) and Colorado (1979–1980).

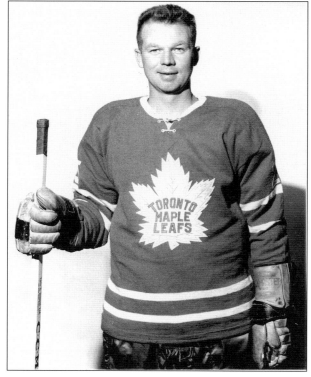

FIVE

Kings of the Ice

The NHL expanded from 6 to 12 teams for the 1967–1968 season. Jack Kent Cooke, chairman of the board of directors of the expansion Los Angeles Kings, was looking for players for his new team and approached Eddie Shore. Shore then sold Cooke the rights to his 29 Springfield players and began leasing the AHL franchise to Cooke on June 5, 1967. Shore still owned the AHL franchise and the lease on the Eastern States Coliseum, but Cooke assumed operation of the AHL club and changed the team name to the Springfield Kings. Shore's role with the team was reduced to scheduling dates for games and practices at the Coliseum and serving as the team's representative on the AHL Board of Governors.

Cooke appointed John Wilson general manager and coach of the team in 1967–1968. Springfield had a 31-33-8 record and made the postseason. The Kings lost in the first round of the Calder Cup playoffs against Providence three games to one. The club missed the playoffs in 1968–1969 with a 27-36-11 record and a last place finish in its four-team division.

Longtime veteran Jimmy Anderson coached part of the 1969–1970 season as John Wilson replaced Los Angeles (NHL) coach Hal Laycoe. The Kings finished in second place with a 38-29-5 record that season and made it all the way to the Calder Cup finals for the first time since 1961–1962. The Kings battled Hershey to a first-round seven-game thriller. In a round-robin semifinal between the locals—the Buffalo Bisons—and the Montreal Voyageurs, Buffalo (3-1 record) and the Kings (2-1 record) advanced to the finals. The Bisons swept Springfield in four straight to take the Calder Cup. Noel Price (defense), who was awarded the AHL's Eddie Shore Award, and Doug Robinson (left wing) were named to the AHL's first team all-stars.

In 1970–1971, Springfield made AHL history by becoming the first team to win a Calder Cup championship with a regular season record of below .500 (29-35-8). The Kings, back under John Wilson, barely got into the playoffs; they were forced to play a game against the Quebec Aces to decide who got the final postseason slot. Once Springfield got over the one-game hump, the club went 10-1 en route to its fourth Calder Cup championship. The Kings swept Montreal in the first round in three games, defeated Cleveland in the second round (three games to one), and then

swept Providence in four to win the championship.

The following season, the Kings had a 31-30-15 third place finish behind new general manager and coach Gary Dineen. Defenseman Noel Price, recipient of his second Eddie Shore Award, and Wayne Rivers (right wing) were selected to the AHL's first all-star team. Springfield lost to Nova Scotia in the first round four games to one.

Prior to the start of the 1972–1973 season, Shore moved the Kings into the new 7,500-seat Springfield Civic Center. During 1972–1973 (18-42-16) and 1973–1974 (21-40-15), Springfield finished second to last and last in its division. Jerry Toppazzini was coach during those two campaigns. In 1973–1974, first-team AHL all-star Gordie Smith (defense) was the winner of the Eddie Shore Award.

Midway through the 1974–1975 season, Jack Kent Cooke threatened to pull all of his players out of Springfield (15 of 19 on the locals' roster) because of mounting financial losses incurred by poor attendance at home games. Competition from the New England Whalers (WHA), who played at the Coliseum during the first-half of the season while awaiting completion of their new home in Hartford, was one reason for the poor turnouts. Springfield was averaging about 2,500 per game, and it was projected that the franchise stood to lose $600,000 that season. The Kings (AHL) had also allegedly lost $800,000 during the past two seasons. Ironically, the story of Cooke's possible withdrawal broke on the day the Whalers played their last game in Springfield. Shore hammered out an agreement with Los Angeles (NHL). Cooke agreed to leave his players in Springfield for the rest of the season and would continue to pay the players, coach, and hockey personnel, while Shore took on the responsibility of the rest of the team's operating expenses.

On February 7, 1975, Shore officially changed the team name back to Indians at a game against Hershey. The switch was well received, as a turnout of 5,787 was on hand for the game. Despite the mid-season adversity, Springfield went on to win its fifth Calder Cup title. The locals finished the regular season at 33-30-12 behind coach Ron Stewart and then skated through the postseason with a 12-5 record. The Indians beat Providence and Rochester in the first two rounds in six games and then took the finals in five against New Haven.

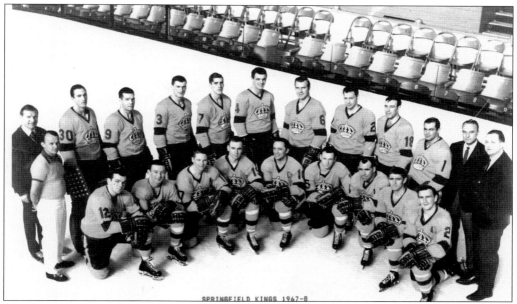

1967–1968 SPRINGFIELD KINGS. Pictured here, from left to right, are the following: (first row) Bill Burnett, Billy Smith, Billy Inglis, Brian Kilrea, Mike Corrigan, Jimmy Anderson, Dennis Rathwell, Gerry Foley, Randy Miller, and Poul Popiel; (second row) coach John Wilson, Jacques Caron, Roger Cote, Rick Pagnutti, Marc Dufour, Paul Jackson, Dave Amadio, Larry Johnston, Yves Locas, George Wood, and two unidentified men.

1967–1968 KINGS INAUGURAL SEASON PROGRAM. The 1967–1968 Springfield squad was composed of players that Los Angeles acquired through the NHL expansion draft (including Mike Corrigan, Marc Dufour, Brent Hughes, Billy Inglis, Poul Popiel, and Doug Robinson) and former Springfield players (including Jimmy Anderson, Roger Cote, Brian Kilrea, and Randy Miller). Kilrea scored the first goal in Los Angeles Kings history.

BILLY SMITH. The Hockey Hall-of-Famer (inducted in 1993) started his professional hockey career in Springfield (1970–1972), where he had a 3.25 GAA and a 32-30-11 record in 77 games. The goaltender was a member of the Kings' 1970–1971 Calder Cup team. Smith won four Stanley Cups (1980, 1981, 1982, and 1983) during his 18-year NHL career and ended with a 3.17 GAA and a 305-233-105 record in 680 games.

BUTCH GORING. Goring won four straight Stanley Cup championships with the Islanders (1980, 1981, 1982, and 1983). The center had a 16-year NHL career (1969–1985) and accumulated 888 points, 375 goals, and 102 PIM in 1,107 games. Goring played two seasons with Springfield (1969–1971) and had 75 points and 36 goals in 59 games. He went on to coach in the NHL with Boston (1985–1987) and the Islanders (1999–2001).

POUL POPIEL. In his six years in the WHA (1972–1978), Popiel had 327 points, 265 assists, and 517 PIM in 468 games and won two Avco World Trophies with Houston (1973–1974 and 1974–1975). He spent two seasons with Springfield (1967–1969), garnering 45 points, 37 assists, and 199 PIM in 85 games. In his seven NHL seasons (between 1965 and 1980), he had 54 points and 210 PIM in 224 games.

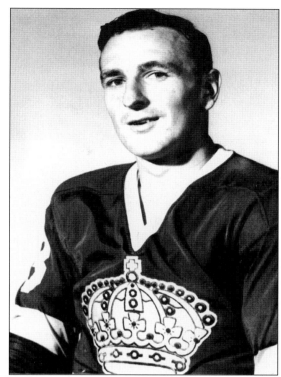

BRUCE LANDON. Landon played four years with Springfield (1969–1972, 1977–1978) and had a 3.99 GAA in 106 games. Landon served as the Indians' general manager from 1982 to 1994. The goalie spent five years in the WHA with New England (1972–1977), playing on its WHA championship team in 1972–1973. He had a 3.43 GAA and a 50-50-9 record in 122 WHA games. Landon has been the Springfield Falcons' president and general manager since 1994–1995.

WAYNE LaCHANCE. LaChance accumulated 128 points, 40 goals, and 206 PIM in 273 games during his four seasons (1970–1974) with the Kings (AHL). The defenseman was a member of Springfield's 1970–1971 Calder Cup team. LaChance also played in the AHL with Syracuse (1974–1975). He was a founder and previous part-owner of the Springfield Falcons (AHL) franchise.

JEAN POTVIN. The defenseman was a member of two Stanley Cup-winning teams with the Islanders (1979–1980 and 1980–1981). The 11-year NHL veteran (1970–1981) had 287 points, 63 assists, and 478 PIM in 613 games. Potvin played for the Kings (AHL) for two seasons (1969–1971), garnering 40 points, 28 assists, and 136 PIM in 121 games. He was a member of the 1970–1971 Springfield championship team.

BILLY INGLIS. Inglis spent four seasons with Springfield (1967–1970, 1975–1976) and collected 244 points and 146 assists in 258 games. A veteran of three NHL seasons (1967–1969, 1970–1971), the center had four points and three assists in 36 games. He won the AHL MVP award and a Calder Cup in 1972–1973 with Cincinnati (AHL). Inglis also won an Adams Cup (CPHL) with Omaha (1963–1964).

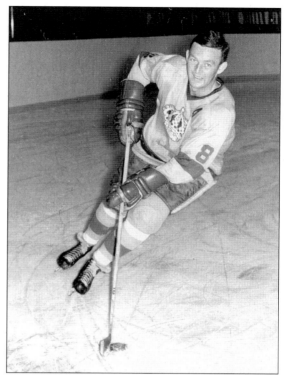

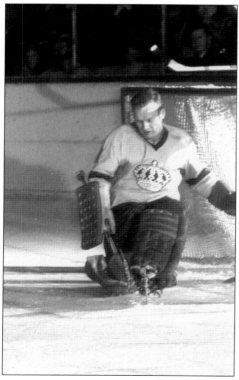

WAYNE RUTLEDGE. In his only season with Springfield (1969–1970), Rutledge had a 4.06 GAA in six games. He played six years in the WHA (1972–1978) and had a 3.26 GAA and a 93-72-7 record in 175 games. He won two Avco World Trophies (WHA) with Houston (1973–1974 and 1974–1975). In three NHL seasons (1967–1970), the netminder had a 3.34 GAA and a 28-37-9 record in 82 games.

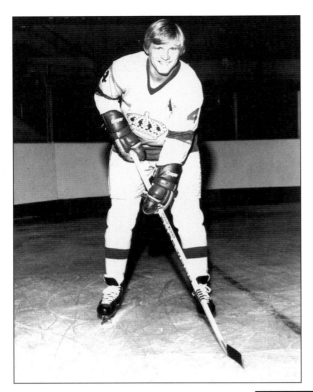

WAYNE CHERNECKI. In his three seasons with Springfield (1971–1974), Chernecki had 166 points and 99 assists in 184 games. He also spent time in the AHL with Providence (1973–1975). The forward was selected by Detroit in round four (No. 45 overall) of the 1969 NHL Amateur Draft.

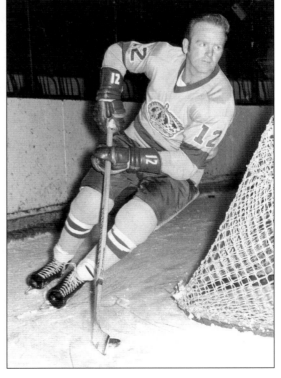

NORM "RED" ARMSTRONG. Armstrong was a member of four Calder Cup teams: Springfield (1970–1971) and Rochester (1964–1965, 1965–1966, and 1967–1968). He garnered 16 points and 15 PIM in 10 games for the Kings (AHL) in 1970–1971. The defenseman had a stint with the Stanley Cup champion Maple Leafs in 1962–1963.

ED HOEKSTRA. Hoekstra had 120 points and 91 assists in 118 games during his two seasons with Springfield (1970–1972). He was a member of the Kings' 1970–1971 Calder Cup team. The center played one season in the NHL with Philadelphia (1967–1968) and had 36 points and 15 goals in 70 games. He played two seasons in the WHA (1972–1974) and skated for Avco World Trophy-winning Houston (1973–1974).

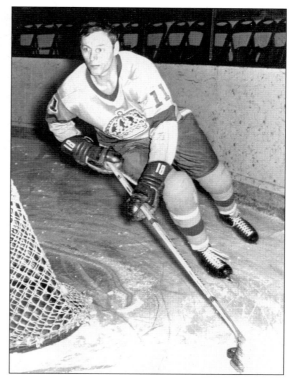

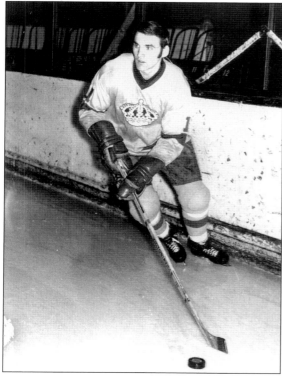

BRENT HUGHES. A veteran of eight NHL seasons (1967–1975), the defenseman had 132 points, 117 assists, and 440 PIM in 435 games. He also spent time in the WHA (1975–1979), collecting 102 points and 180 PIM in 268 games. In his two seasons (1967–1968, 1969–1970) with the Kings (AHL), Hughes had 19 points, 14 assists, and 40 PIM in 28 games.

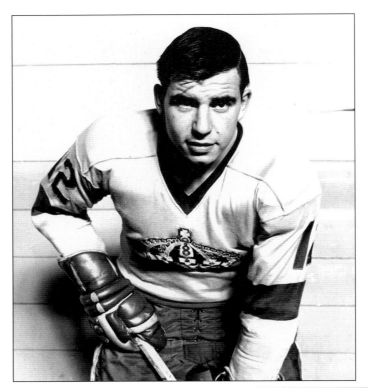

GARY CROTEAU. Croteau skated in two seasons (1968–1970) with the Kings (AHL), totaling 88 points and 47 goals in 105 games. The left winger spent 12 years in the NHL (1968–1980) and had 319 points, 144 goals, and 143 PIM in 684 games.

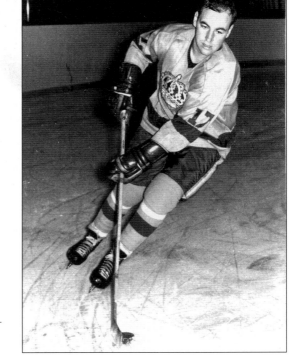

MIKE CORRIGAN. The 10-year NHL veteran (1967–1968, 1969–1978) had 347 points, 195 assists, and 698 PIM in 594 NHL games. Corrigan, a left winger, played three seasons in Springfield (1967–1970) and garnered 129 points, 60 goals, and 191 PIM in 161 games.

BRIAN GIBBONS. In his three seasons (1969–1972) with the Kings (AHL), Gibbons had 24 points, 8 goals, and 250 PIM in 153 games. The defenseman also spent four years in the WHA (1972–1976), where he collected 103 points, 88 assists, and 251 PIM in 226 games.

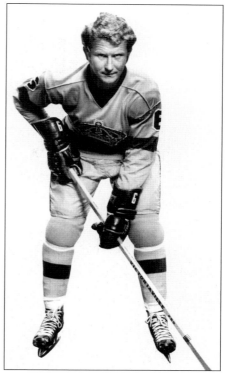

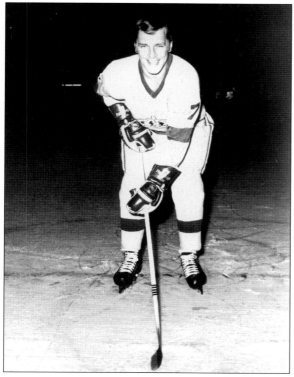

REAL LEMIEUX. Lemieux played with the Kings' 1970–1971 Calder Cup-winning team. The right winger had 36 points and 14 goals in 33 games that season. Lemieux spent eight years in the NHL (1966–1974) and had 155 points, 104 assists, and 262 PIM in 483 games.

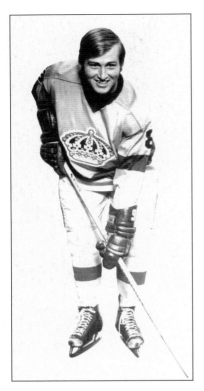

PHIL HOENE. The left winger played four seasons with Springfield (1971–1975) and had 108 points, 95 goals, and 203 PIM in 247 games. He was a member of the 1974–1975 Springfield Calder Cup team. Hoene skated in three NHL seasons (1972–1975) and registered six points and 22 PIM in 37 games.

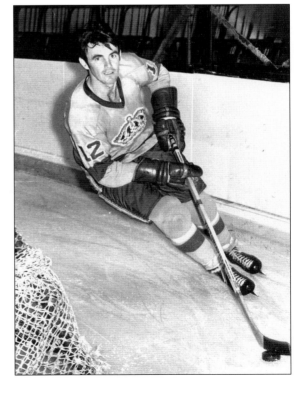

DON WESTBROOKE. Westbrooke had 27 points and 18 goals in 49 games with the 1970–1971 champion Kings (AHL). He was a member of five Turner Cup (IHL) championship teams: Toledo (1963–1964, 1966–1967, and 1974–1975) and Dayton (1968–1969 and 1969–1970). The right winger also played with Springfield during the 1963–1964 season and scored one point in five games.

DAVE AMADIO. Amadio played eight seasons with Springfield (1961–1968, 1969–1970) and had 198 points, 139 assists, and 687 PIM in 468 games (sixth all-time in Indians/Kings history). He skated in three NHL seasons (1957–1958, 1967–1969), garnering 16 points and 163 PIM in 125 games. The defenseman also played on the Indians' 1961–1962 Calder Cup team.

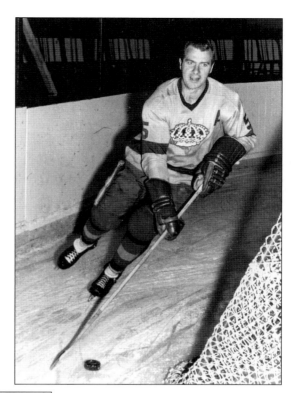

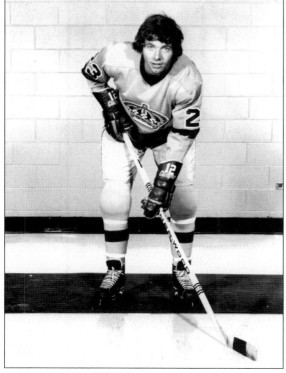

JOHN HEALEY. The center played four seasons (1970–1974) with the Kings (AHL), collecting 151 points and 61 goals in 264 games. He was a member of the 1970–1971 Springfield Calder Cup team. Healey also won an Adams Cup (CHL) with Salt Lake City in 1974–1975.

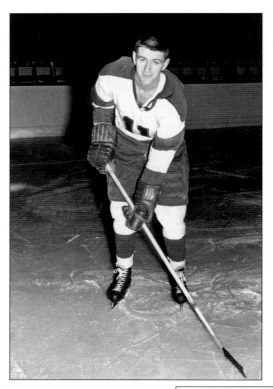

RANDY MILLER. Miller ranks 10th in games played (409) in Indians/Kings history. In his nine seasons with Springfield (1963–1971, 1972–1973), he had 251 points, 100 goals, and 336 PIM. He was a member of the Kings' 1970–1971 Calder Cup team. The left winger also won a Foley Trophy (EPHL) with Kingston (1962–1963).

BRIAN MURPHY. Murphy was a member of the Kings' 1970–1971 Calder Cup team. In his three years with Springfield (1968–1971), the forward had 65 points, 26 goals, and 73 PIM in 195 games. He had a stint in the NHL with Detroit (1974–1975) and spent five other seasons in the AHL (1971–1976) with Baltimore, Virginia, and Rochester.

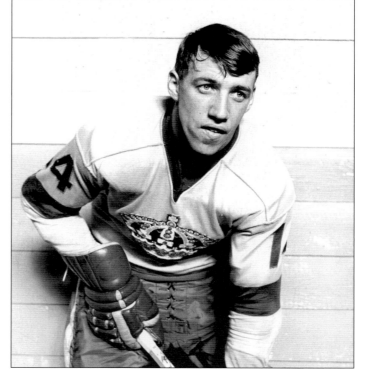

1971–1972 SPRINGFIELD PROGRAM. This program commemorates Springfield's fourth Calder Cup championship captured during the previous season. The 1970–1971 Kings were the first team to win a Calder Cup with a losing regular season record (29-35-8).

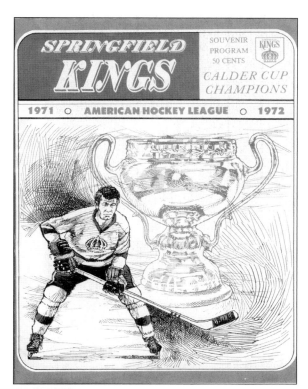

GARY DINEEN. Dineen was a member of the Canadian National Team for five years (1963–1968). In his two seasons with Springfield (1969–1971), he had 37 points and 24 assists in 64 games. The center was a member of the 1970–1971 Kings championship team and was coach of the squad during the following season. He had a stint in the NHL with Minnesota (1968–1969).

BRYAN CAMPBELL. Campbell played two years in Springfield (1968–1970), collecting 76 points and 34 goals in 68 games. The center had 106 points and 35 goals in 260 games during his five NHL seasons (1967–1972). During his six years in the WHA (1972–1978), he totaled 376 points, 123 goals, and 219 PIM in 433 games.

KENT BYRNES. Byrnes had three points and two assists in 16 games with the 1970–1971 Calder Cup champion Kings. He played part of the 1970–1971 season with Montreal (AHL) and spent time in the IHL (1968–1969, 1971–1972) with Muskegon, Port Huron, and Toledo. The left winger also played one season in the WHL with Denver (1969–1970).

1974–1975 SPRINGFIELD PROGRAM.
Shortly after Los Angeles (NHL) owner Jack Kent Cooke re-negotiated his financial obligation to the Springfield club with Eddie Shore, Shore took the liberty of re-establishing the team name that had been synonymous with hockey in Springfield. In the club's first game back as the Indians, on February 7, 1975, Shore dropped the first puck and wore an Indian headdress to observe the occasion.

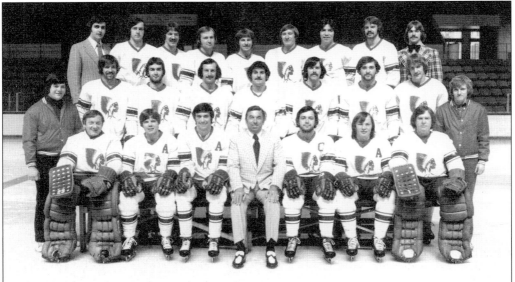

1974–1975 SPRINGFIELD INDIANS. Shown here, from left to right, are the following: (first row) Rick Carron, Paul Shakes, Jim Peters, coach Ron Stewart, Mark Heaslip, Tim Jacobs, and Steve Rexe; (second row) Eddie Tyburski, Dale Lewis, Dennis Abgrall, Murray Flegel, Ernie Moser, Pete Harasym, Jim Weatherspoon, Roger Lemelin, and Ralph Calvanese; (third row) Jim Slattery, Ken Murray, Barry Cummins, Phil Hoene, Bob Poffenroth, Jim Nichols, Tom Cassidy, Lorne Stamler, and Harvey Stewart.

DENNIS HEXTALL. In his only season with Springfield (1969–1970), Hextall played in 10 games and had 13 points, 5 goals, and 52 PIM. The left winger played 13 years in the NHL (1967–1980) with six different teams and amassed 1,398 PIM, 503 points, and 153 goals in 681 games.

DON MCLEOD. In two years with Springfield (1967–1969), McLeod posted a 3.34 GAA and a 21-15-3 record in 43 games. He later spent six years in the WHA (1972–1978) and had a 3.33 GAA and a 157-143-15 record in 332 games. The goaltender won an Avco World Trophy (WHA) with Houston (1973–1974). He also played in two NHL seasons (1970–1972) and had a 5.05 GAA and a 3-10-1 record in 18 games.

FIVE

The Later American Hockey League Years

The 1975–1976 campaign was the first full season that the club was known as the Indians since 1966–1967. All-time Springfield great Jimmy Anderson coached the team, Shore operated it, and Kansas City (NHL) was its affiliation. Springfield finished in last place in its four-team division and had a 33-39-4 record. On July 4, 1976, Eddie Shore, at age 73, sold the team to his attorney, George Leary. The Indians had won five Calder Cups during the Shore era (second only to Cleveland, with nine). Leary then moved the club back to the Eastern States Coliseum, where it would play its home games through the 1979–1980 season.

Springfield had its first AHL scoring champion in 14 years as Andre Peloffy led the AHL in points (99) in 1976–1977. The club, now affiliated with Philadelphia (NHL) and Washington (NHL), finished with a 28-51-1 record, short of the playoffs. John Hanna, who had piloted the team, was replaced mid-season by Gary Dineen.

Springfield made the playoffs in 1977–1978 with a 39-33-9 record behind coach Gary Dineen and his mid-season replacement Bob Berry (player and coach), but was eliminated in the first round by Nova Scotia (three games to one). Los Angeles (NHL) and New England (WHA) became the Indians' parent clubs. Mario Lessard (goalie) and Charlie Simmer (left wing) were both named to the AHL's second all-star team.

The Indians then had five consecutive regular seasons below .500 (1978–1979 to 1982–1983). Over that period, the tribe only made the playoffs once, in 1980–1981, but lost in the first round to Maine in seven games. The club had six different coaches during those five seasons: Ted Harris and Pete Stemkowski (1978–1979), Larry Kish (1979–1980), John Wilson (1980–1981), Tom Webster (1981–1982), and Orland Kurtenbach (1982–1983). The Indians also had several major league affiliations over that period: Los Angeles and New England (1978–1979), Hartford (1979–1980), Boston (1980–1981), the Rangers (1981–1982), and Chicago (1982–1983). In 1979–1980, Springfield's Bruce Landon won the AHL's Ken McKenzie Award for Outstanding Executive—PR and Marketing, while Bob Janecyk (goalie) was named an AHL first-team all-star in 1982–1983.

In 1983–1984, the Indians had their first winning regular season (39-35-6) in six years, behind coach Doug Sauter. Springfield was now affiliated with both Philadelphia and Chicago. The tribe made the playoffs, but was swept in four games in the first round against Baltimore. Springfield's Jack Butterfield received the AHL's James C. Hendy Memorial Award for Outstanding Executive.

During the next five seasons (1984–1985 to 1988–1989), Springfield had sub-.500 regular season performances and made the playoffs only once (1984–1985, losing to Binghamton 4-0 in the first round). The club, however, had some outstanding individuals coaching the team during this period: four-time Stanley Cup winner Lorne Henning (1984–1985), 1970–1971 *Hockey News* Minor League Coach of the Year Fred Creighton (1985–1987), four-time Stanley Cup winner Gord Lane (1987–1988), and five-time Stanley Cup winner Jimmy Roberts (1988–1989). There were also some standout performances: Bruce Boudreau led the league in scoring (116 points) and was awarded the AHL's Fred T. Hunt Memorial Award for Sportsmanship, Determination, and Dedication to Hockey during the 1987–1988 season, and general manager Bruce Landon was awarded the James C. Hendy Memorial Award in 1988–1989.

1979–1980 PROGRAM. In 1979–1980, the Springfield Indians were the top farm team of the Hartford Whalers (NHL). The affiliation was unique during the first half of the season because the Whalers were based in Springfield. To report to the big club, players only had to travel across town. Mike Antonovich, Marty Howe, and Tim Sheehy were among those players who skated for both teams that season.

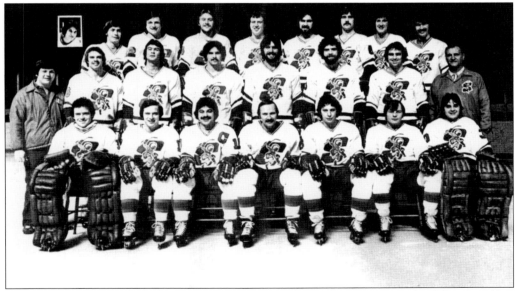

1977–1978 SPRINGFIELD INDIANS. Pictured here, from left to right, are the following: (first row) Eddie Walsh, Dave Hynes, Andre Peloffy, coach Bob Berry, Paul McIntosh, Tim Jacobs, and Mario Lessard; (second row) Ed Tyburski, Lorne Stamler, Russ Walker, Steve Short, Charlie Simmer, Pete Laframboise, Jim Moxey, and Hamm Fabbri; (third row) Steve Clippingdale (inset), Danny Arndt, Michel Dubois, Jim Kirkpatrick, Andre Leduc, Jim Mayer, Tom Price, Derek Haas, and Pat Russell.

STEVE CARLSON. In his two seasons with Springfield (1977–1978, 1980–1981), the center collected 60 points, 31 goals, and 92 PIM in 69 games. In the WHA (1975–1979), Carlson had 80 points, 33 goals, and 132 PIM in 173 games. In the NHL (1979–1980), he tallied 21 points, 9 goals, and 23 PIM in 52 games. Carlson won a Lockhart Cup (NAHL) with Johnstown (1974–1975) and appeared in the movie *Slap Shot*.

RICHARD SEVIGNY. The 1980–1981 NHL Vezina Trophy winner was between the pipes in 22 games for the Indians during the 1978–1979 season. He had a 3.55 GAA and a 6-12-3 record for the tribe. In his eight NHL seasons (1979–1987), Sevigny had a 3.21 GAA and an 80-54-20 record in 176 games.

ANDRE PELOFFY. Peloffy had 265 points, 105 goals, and 323 PIM in 230 games during his four seasons with the Indians (1976–1979, 1980–1981). He won the John B. Sollenberger Trophy for AHL Leading Scorer in 1976–1977 while with Springfield. The center played briefly in the NHL with expansion Washington in its inaugural season (1974–1975). He also had a stint in the WHA with New England (1977–1978).

BARRY MELROSE. An analyst on ESPN's *Hockey Night*, Melrose won a Calder Cup with Adirondack as a player in 1985–1986 and then as a general manager and coach in 1991–1992. In 1976–1977, with the Indians, the defenseman had three points and 17 PIM in 23 games. Melrose, a veteran of six NHL seasons (1979–1984, 1985–1986), registered 33 points and 728 PIM in 300 games. He also played in the WHA (1976–1979).

MIKE KRUSHELNYSKI. A veteran of 14 NHL seasons (1981–1995), Krushelnyski registered 569 points, 241 goals, and 699 PIM in 897 games. He was a member of three Stanley Cup-winning teams with Edmonton (1984–1985, 1986–1987, and 1987–1988). In his one season with Springfield (1980–1981), the forward had 53 points, 25 goals, and 47 PIM in 80 games.

CHARLIE SIMMER. Simmer collected 119 points and 55 goals in 114 games during his two seasons with the Indians (1977–1979). He registered about one point per game (711 points in 712 games) during his 14 seasons in the NHL (1974–1988). The left winger also had 342 goals and 544 PIM in the bigs. Simmer was awarded the Bill Masterton Trophy in 1985–1986.

CRAIG MACTAVISH. In 17 NHL seasons
(1979–1984, 1985–1997), MacTavish
registered 480 points, 213 goals, and
891 PIM in 1,093 games. He was a
member of four Stanley Cup-winning
teams with Edmonton (1986–1987,
1987–1988, and 1989–1990) and the
Rangers (1993–1994). The center had 43
points, 19 goals, and 81 PIM in 53 games
with Springfield (1980–1981). He also
coached in the NHL (2000–2004).

BOB POFFENROTH. The right winger played
four seasons in Springfield (1971–1973, 1974–
1976) and had 161 points, 95 assists, and 65
PIM in 266 games. Poffenroth also played in
the WHL with Portland (1973–1974).

PETE STEMKOWSKI. Stemkowski played on two Stanley Cup-winning teams with Toronto (1963–1964 and 1966–1967). He appeared in 15 NHL seasons (1963–1978), totaling 555 points, 206 goals, and 866 PIM in 967 games. The center played and then coached the Indians during the 1978–1979 season. He had 15 points and 12 assists in 24 games that season.

JOHN PADDOCK. Paddock is the only coach in AHL history to pilot three different teams to Calder Cup titles: Maine (1983–1984), Hershey (1987–1988), and Hartford (1999–2000). Paddock had 29 points, 13 goals, and 106 PIM in 61 games with Springfield (1976–1977). The right winger is a five-year NHL veteran (between 1975 and 1983), registering 22 points and 86 PIM in 87 games.

PAT CONACHER. Conacher was a veteran of 13 NHL seasons (between 1979 and 1996). He had 139 points, 63 goals, and 235 PIM in 521 NHL games. He skated for one season with Springfield (1981–1982), tallying 45 points, 23 goals, and 38 PIM in 77 games. The left winger won a Stanley Cup with Edmonton (1983–1984) and played for the Canadian National Team (1997–1998).

STEVE VICKERS. Vickers was the Rangers' number one draft pick (No. 10 overall) during the 1971 NHL Amateur Draft. He won the NHL's Calder Memorial Trophy for Rookie of the Year in 1972–1973. In his 10 NHL seasons with the Rangers (1972–1982), he had 586 points and 246 goals in 698 games. The left winger totaled 10 points, 4 goals, and 14 PIM in 20 games with Springfield (1981–1982).

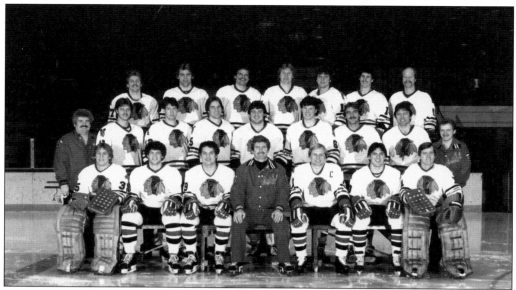

1982–1983 SPRINGFIELD INDIANS. Shown here, from left to right, are the following: (first row) Jim Ralph, Louis Begin, Perry Pelensky, coach Orland Kurtenbach, Bud Stefanski, Dan Frauleuy, and Bob Janecyk; (second row) Randy Lacey, Don Deitrich, Steve Blyth, Len Dawes, Darrel Anholt, Jerome Dupont, Miles Zaharko, Rob Flockhart, and Ralph Calvanese; (third row) Bart Yachimec, Rod Willard, Sean Simpson, Brian Shaw, Marcel Frere, Bob Miller, and Reg Kerr.

DAVE MICHAYLUK. Michayluk ranks first all-time in goals (547), third all-time in points (1,183), and fourth all-time in assists (636) and games (968) in IHL history. In 1983–1984, with the Indians, he had 62 points and 18 goals in 79 games. He won two Turner Cups (IHL) with Muskegon (1985–1986 and 1988–1989). The left winger also played three years in the NHL (1981–1983, 1991–1992).

MICHEL "BUNNY" LAROCQUE. Larocque
won four Stanley Cups (1976, 1977, 1978,
and 1979) and shared the Vezina Trophy
four times (1977, 1978, 1979, and 1981)
while playing with Montreal (NHL).
Bunny earned a 3.33 GAA and a 160-89-
45 record in 312 games during 11 NHL
seasons (1973–1984). The netminder had
a stint with Springfield in 1983–1984,
ending with a 4.18 GAA and a 3-2 record
in five games.

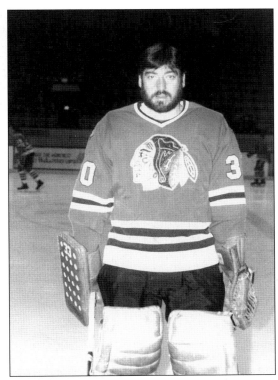

1983–1984 SPRINGFIELD PROGRAM.
The Indians had a split affiliation
with the Chicago Black Hawks and
Philadelphia Flyers during the 1983–
1984 season. Philadelphia farmhands
included Dave Brown, Lindsay Carson,
Michel Larocque, Dave Michayluk,
and Daryl Stanley. Denis Cyr, Jerome
Dupont, Dan Frawley, Bob Janecyk,
and Peter Marsh were among the
Chicago assignees.

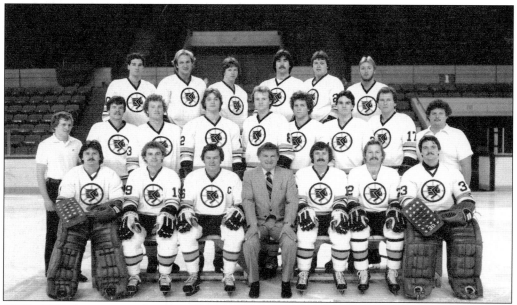

1980–1981 SPRINGFIELD INDIANS. Pictured here, from left to right, are the following: (first row) Roy Schultz, Randy Wilson, Ron Plumb, coach John Wilson, Guy Delparte, Jim Turkiewicz, and Marco Baron; (second row) Ralph Calvanese, Andy Spruce, Keith Crowder, Mike Krushelnyski, Brian McGregor, Craig MacTavish, Randy Hillier, Tom Songin, and Mike Parisi; (third row) Barry Ryan, Bob Stephanson, Gary MacGregor, Tom Price, Doug Butler, and Larry Skinner.

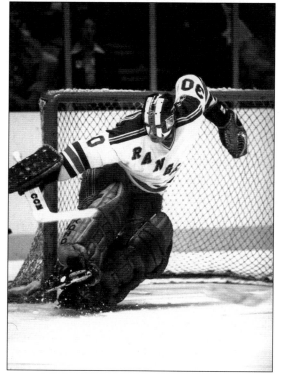

JOHN DAVIDSON. Davidson was between the pipes in eight games for the Indians during the 1981–1982 season. He had a 3.30 GAA and a 3-4-0 record with Springfield. The goalie was a 10-year NHL veteran (1973–1983) with St. Louis and the Rangers. He had a 3.52 GAA and a 123-124-39 record in 301 NHL games.

DAVE BROWN. Brown played for the Indians during the 1983–1984 season, totaling 31 points, 17 goals, and 150 PIM in 59 games. He is a 14-year NHL veteran (1982–1996) with Philadelphia, Edmonton, and San Jose. The right winger produced 97 points, 45 goals, and 1,789 PIM in 729 games. He was a member of Stanley Cup-winning Edmonton in 1989–1990.

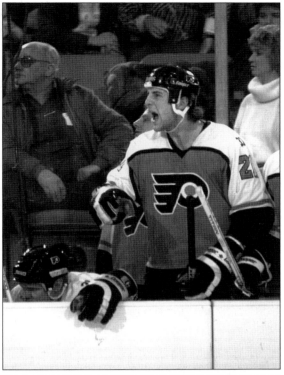

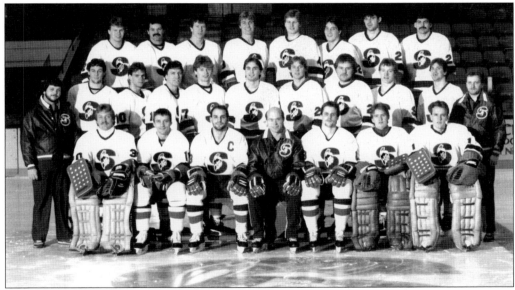

1984–1985 SPRINGFIELD INDIANS. Team members, from left to right, were as follows: (first row) Lorne Molleken, Tim Coulis, Tim Trimper, coach Lorne Henning, Chris Pryor, Mike Sands, and Todd Lumbard; (second row) unidentified, Terry Tait, Scott Howson, Rob Flockhart, Jiri Poner, Vern Smith, Bob Bodak, Dale Henry, Alan Kerr, Tom Hirsch, and Ralph Calvanese; (third row) Roger Kortko, Dirk Graham, Gord Dineen, Randy Velischek, David Jensen, Monty Trottier, unidentified, and Mark Hamway.

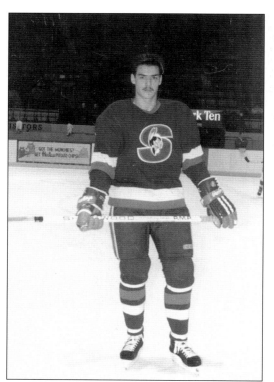

GERALD DIDUCK. Diduck played 17 seasons in the NHL (1984–2001) with eight teams, accumulating 1,612 PIM, 212 points, and 156 assists in 932 games. In his two seasons with the Indians (1985–1987), he had 293 PIM, 34 points, and 22 assists in 106 games. The defenseman played for the Canadian National Team in 1999–2000.

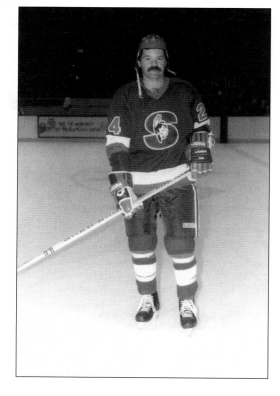

DIRK GRAHAM. Graham skated for Springfield during the 1984–1985 season, totaling 48 points and 20 goals in 37 games. In 12 NHL seasons (1983–1995), the forward had 489 points, 219 goals, and 917 PIM in 772 games with Minnesota and Chicago. He was awarded the NHL's Selke Trophy for Best Defensive Forward in 1990–1991. Graham currently coaches the Springfield Falcons.

GORD LANE. Prior to coming to Springfield in 1986–1987, Lane won four consecutive Stanley Cups with the Islanders (1980, 1981, 1982, and 1983). In 62 games with the Indians, he garnered eight points, six assists, and 117 PIM. During his 10 years in the NHL (1975–1985), the defenseman had 113 points and 1,228 PIM in 539 games. He coached Springfield in 1987–1988.

BRUCE BOUDREAU. Boudreau ranks 11th all-time in points (799) and assists (483) and 13th all-time in goals (316) in AHL history. During his seasons with Springfield (1987–1989), he had 180 points and 110 assists in 130 games. The center spent eight seasons in the NHL (1976–1983, 1985–1986), where he totaled 70 points and 28 goals in 141 games. He set the Indians/Kings all-time single-season record for points (116) and assists (74) in 1987–1988.

1985–1986 SPRINGFIELD INDIANS. Pictured here, from left to right, are the following: (first row) Bill Stewart, Jon Casey, Ron Handy, Chris Pryor, coach Fred Creighton, Terry Martin, Don Biggs, Mike Sands, and Gary Lacey; (second row) Ed Tyburski, Bob Bodak, unidentified, Jim Archibald, Mike Walsh, Vern Smith, Alan Kerr, Terry Tait, Glen Johannesen, Gerald Diduck, and Ralph Calvanese; (third row) Ken Leiter, George Servinis, Jim Koudys, Gord Dineen, Neal Coulter, Dale Henry, David Jensen, and Kari Takko.

MICK VUKOTA. In 11 NHL seasons, the right winger accumulated 2,071 PIM, 46 points, and 29 assists in 574 games. In 1987–1988, Vukota set the all-time single-season PIM mark in Indians/Kings history with 372. In his two seasons with Springfield (1987–1989), he totaled 408 PIM, 17 points, and 8 goals in 55 games.

AL SECORD. The number one draft pick (No. 16 overall) of Boston in the 1978 NHL Amateur Draft, Secord played one season in Springfield (1980–1981). He had eight points, five assists, and 21 PIM in eight games for the Indians. The left winger amassed 2,093 PIM, 495 points, and 273 goals in 766 NHL games during his 12-year NHL career (1978–1990).

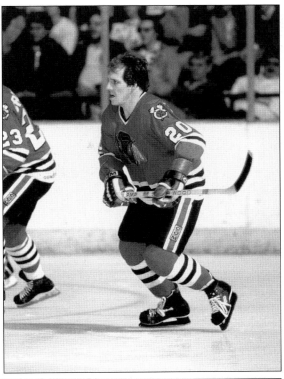

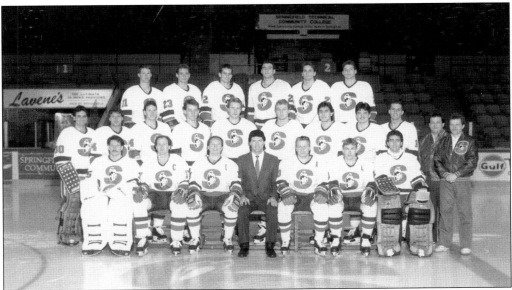

1987–1988 SPRINGFIELD INDIANS. Shown here, from left to right, are the following: (first row) Brian Ford, Neal Coulter, Bruce Boudreau, coach Gord Lane, John Mokosak, Gord Paddock, Marty Wakelyn, Ed Tyburski, and Ralph Calvanese; (second row) Royden Gunn, Jim McGeough, Stu Burnie, Bill Berg, Ari Haanpaa, Dale Kushner, Alain Lemieux, Todd McLellan, and Duncan MacPherson; (third row) Kevin Herom, Kurt Lackten, Rod Dallman, Mick Vukota, Vern Smith, and Mike Walsh.

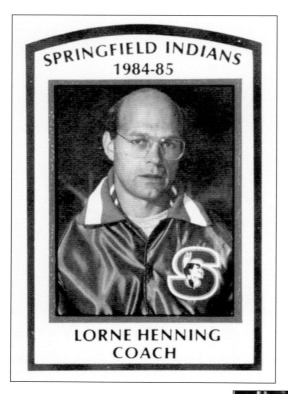

SPRINGFIELD INDIANS
1984-85

LORNE HENNING
COACH

LORNE HENNING. Henning won four consecutive Stanley Cups with the Islanders (1980, 1981, 1982, and 1983 [two as a player and two as an assistant coach]) prior to piloting the Indians in 1984–1985. In his one season as Springfield coach, the team was 36-40-4 (.475 pct). Henning went on to coach in the NHL with Minnesota (1985–1987) and the Islanders (1994–1995, 2000–2001) and had an 87-111-25 record (.446 pct).

MIKE ANTONOVICH. The center spent two seasons with Springfield (1978–1980) and had 25 points and 16 goals in 31 games. Antonovich appeared in all seven seasons of the WHA (1972–1979), collecting 370 points and 182 goals in 485 games. He played in five NHL seasons (between 1975 and 1984), in which he scored 25 points and 15 assists in 87 games.

SIX

Two Seasons, Two Affiliations, and Two Calder Cups

The Springfield Indians were the last team in AHL history to win consecutive Calder Cups, in 1989–1990 and 1990–1991. The back-to-back championships were even more unique because they were accomplished with two different NHL affiliations. The Indians were the farm team of the New York Islanders (NHL) from 1984 to 1990 (the affiliation was shared with Minnesota from 1984 to 1987). In 1990–1991, the Hartford Whalers (NHL) formed a working agreement with Springfield which would last through the 1993–1994 season. The Indians literally won two AHL titles in two seasons with entirely different teams. Only two players—Marc Bergevin and Dale Henry—were members of both championship squads. Jimmy Roberts was coach of the team and former Springfield player Bruce Landon was general manager during both seasons.

In 1989–1990, Springfield made the playoffs for the first time since the 1983–1984 season with a third-place finish in its division (38-38-4 record). Coach Jimmy Roberts's Indians turned in a strong second half to reach the .500 level and carried the momentum into the playoffs. The locals beat Cape Breton in the opening round four games to two. They then beat Northern Division champion Sherbrooke in six games in the semifinals. In their first Calder Cup finals appearance in 15 years, the Indians defeated Southern Division champion Rochester in six games to capture their sixth Calder Cup championship. Roberts was awarded the AHL's Louis A. R. Pieri Memorial Award for Coach of the Year for his outstanding job behind the bench.

The Indians (now affiliated with Hartford) clinched their first division title since the 1961–1962 season, winning the Northern Division crown in 1990–1991 with a 43-27-10 record. Coach Roberts showed that he could work his magic again, taking a Springfield line-up filled with players that had finished with the third worst full regular season record in AHL history the season before in Binghamton (11-60-9, .194 pct) and making them champions. The locals beat Fredericton in the quarter-final round of the playoffs in seven games. In the semifinals, the Indians defeated Moncton four games to one. The Indians again won the Calder Cup by beating Southern Division champion Rochester in six games. Springfield's seventh Calder Cup title tied them with Hershey for the second most of all-time (behind Cleveland's nine). Whaler

farmhands Michel Picard (sixth, 96 points) and James Black (seventh, 96 points) both placed in the AHL's top 10 in points scored. Picard's 56 goals were the most scored in a single season in Indians/Kings history. Kay Whitmore was the AHL's fourth leading goaltender with a 3.07 GAA in 33 games.

The tribe looked like they were on their way to a three-peat in 1991–1992 with another division title and a 43-29-8 record. Under new coach Jay Leach, Springfield beat Capital District (the New York Islander affiliate since last season) in the first round in seven games. The locals, however, were swept in four straight in the second round to Adirondack, who would go on to win the Calder Cup. Shawn Evans (defense) and Chris Tancill (right wing) were named AHL first team all-stars.

The Indians celebrated their golden anniversary AHL season in 1992–1993. It was the 50th season that Springfield's AHL franchise took to the ice (1936–1942, 1946–1951, and 1954–1993). The team had a losing season (25-41-14), but nevertheless almost made it to the Calder Cup finals. In the playoffs, the Indians upset Northern Division champion Providence four games to two. The locals then knocked off defending Calder Cup champion Adirondack in seven games. In a best-of-three semifinal, coach Jay Leach's club fell short against Cape Breton in two straight games.

The following season, in 1993–1994, the locals again edged into the playoffs with a losing record (29-38-13), coached by Joel Quenneville. Springfield lost in the opening round to Adirondack four games to two. Rob Cowie (defense) was named an AHL second team all-star. It would turn out to be the last season of the storied Springfield Indians club. Owner Peter Cooney, former Indians' radio broadcaster who had bought the club from George Leary prior to the 1982–1983 season, sold the team to a group of Worcester, Massachusetts, investors headed by Roy Boe. Cooney put the club on the market because of financial losses due to shrinking attendance figures. Attendance declined 22 percent over the past five years—from an average of 4,071 in 1989–1990 to an average of 3,189 in 1993–1994. It was reported that the Indians needed to draw 4,200 per game to break even in 1993–1994. The Springfield franchise was transferred to Worcester and was renamed the Worcester IceCats for the 1994–1995 season.

JIMMY ROBERTS. Coach Roberts piloted the Indians for three seasons (1988–1991), leading them to the AHL's last back-to-back Calder Cup championships (1989–1990 and 1990–1991). He compiled a 113-109-18 (.508 pct) record in Springfield. As a player, the defenseman had 320 points and 194 assists in 1,006 games during his 14-year NHL career (1964–1978). Roberts was also a member of four Stanley Cup-winning teams.

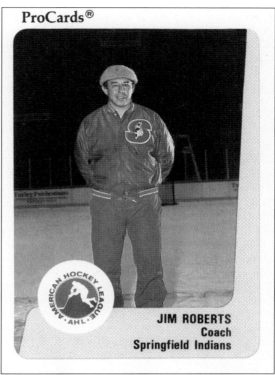

ProCards®

JIM ROBERTS
Coach
Springfield Indians

DEREK KING. King was the Islanders' number two pick (No. 13 overall) in the 1985 NHL Entry Draft. A veteran of 14 NHL seasons (1986–2000), he accumulated 612 points, 261 goals, and 417 PIM in 830 games. In his three years with Springfield (1987–1990), the left winger had 40 points, 22 goals, and 39 PIM in 35 games. He was a member of the Islander Calder Cup team (1989–1990).

JOHN STEVENS. Stevens won three Calder Cups as a player (Hershey 1987–1988, Springfield 1990–1991, and Philadelphia 1997–1998) and one as a coach (Philadelphia 2004–2005). He had 57 points, 52 assists, and 408 PIM in 255 games with the Indians (1990–1994). The defenseman played five seasons in the NHL (between 1986 and 1994), garnering 10 points and 48 PIM in 53 games. He also played with the Springfield Falcons (1994–1996).

JEFF HACKETT. Hackett was awarded the Jack Butterfield Trophy as Calder Cup MVP during the Indians' 1989–1990 championship season. In his two seasons with Springfield (1988–1990), Hackett had a 36-39-5 record and a 3.85 GAA in 83 games. A veteran of 15 NHL seasons (1988–1989, 1990–2004), the goaltender had a 2.90 GAA, 26 shutouts, and a 166-244-56 record in 500 games.

MIKE TOMLAK. Tomlak played four seasons with Springfield (1990–1994), including the 1990–1991 championship team. Tomlak had 187 points, 80 goals, and 148 PIM in 171 games. The forward spent four seasons in the NHL (1989–1992, 1993–1994), where he totaled 37 points, 22 assists, and 103 PIM in 141 games.

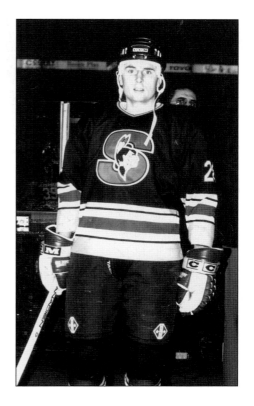

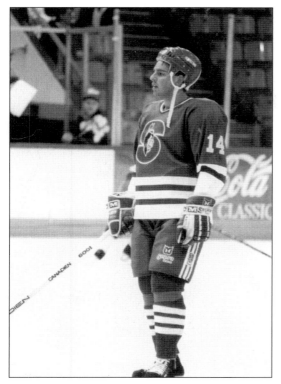

CHRIS GOVEDARIS. A member of the Whaler Calder Cup team in 1990–1991, Govedaris had 156 points, 71 goals, and 246 PIM in 164 games during his three years with Springfield (1990–1993). The left winger had four stints in the NHL (1989–1991, 1992–1994) and collected 10 points, 4 goals, and 24 PIM in 45 games.

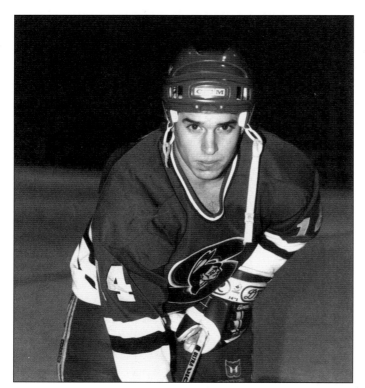

MARK GREIG. In his four years with Springfield (1990–1994), Greig totaled 196 points, 124 assists, and 218 PIM in 182 games. The right winger was the number one draft pick by Hartford (No. 15 overall) during the 1990 NHL Entry Draft. He spent nine years in the NHL (between 1990 and 2003), garnering 40 points and 90 PIM in 125 games. Greig played for the 1990–1991 Calder Cup team.

TERRY YAKE. A veteran of 11 NHL seasons (1988–1995, 1997–2001), Yake had 197 points, 77 goals, and 220 PIM in 403 games. In his three seasons with the Indians (1990–1993), the center had 154 points, 64 goals, and 146 PIM in 129 games. He was a member of the 1990–1991 Calder Cup team.

TOM FITZGERALD. The forward was the Islanders' number one pick (No. 17 overall) of the 1986 NHL Entry Draft. He went on to a 16-year NHL career (1988–2004), accumulating 319 points, 135 goals, and 736 PIM in 1,026 games. In his two years with the Indians (1988–1990), Fitzgerald had 95 points, 54 goals, and 75 PIM in 114 games. He was a member of the 1989–1990 championship team.

JAMES BLACK. A member of the 1990–1991 Calder Cup team, Black had 136 points and 86 assists in 126 games during his two seasons with Springfield (1990–1992). The defenseman played 11 seasons in the NHL (1989–1994, 1995–2001) with five different teams and garnered 115 points, 58 goals, and 84 PIM in 352 games.

JOE DAY. In his three seasons with Springfield (1990–1993), Day totaled 146 points, 72 goals, and 292 PIM in 158 games. The center played on the 1990–1991 Calder Cup team. He also spent three seasons in the NHL (1991–1994) and registered 11 points, 10 assists, and 87 PIM in 72 games. He won a Colonial Cup (UHL) with Muskegon in 2003–2004.

KAY WHITMORE. Whitmore was awarded the Jack Butterfield Trophy for his play during the 1990–1991 Calder Cup playoffs. In his only season in Springfield, the goaltender had a 3.07 GAA and a 22-9-1 record in 33 games. A veteran of nine NHL seasons (1988–1995, 2000–2002), Whitmore had a 60-64-16 record and a 3.55 GAA in 155 games.

JEFF FINLEY. A veteran of 15 NHL seasons (between 1987 and 2004), Finley collected 83 points, 70 assists, and 457 PIM in 708 games. He played three seasons with the Indians (1987–1990) and had 58 points, 49 assists, and 146 PIM in 174 games. Finley skated for the 1989–1990 Calder Cup team. The defenseman also played for the Springfield Falcons (1995–1996).

SCOTT HUMENIUK. In his four years with the Indians (1990–1994), Humeniuk had 88 points, 23 goals, and 215 PIM in 172 games. He was a member of the Whaler Calder Cup team in 1990–1991. The defenseman also skated for Calder Cup-winning Rochester (1995–1996).

ROD DALLMAN. Dallman is the all-time PIM leader (844) in Indians/Kings history. During his three seasons in Springfield (1987–1990), he totaled 80 points and 31 goals in 169 games. Dallman also had four stints in the NHL (1987–1990, 1991–1992). The left winger is the only Indian player to have two seasons of over 300 PIM—355 in 1987–1988 and 360 in 1988–1989. He was a member of the 1989–1990 Calder Cup team.

1993–1994 SPRINGFIELD PROGRAM. This season was the last for the Springfield Indians, the last original AHL franchise still existing in its original city. At the time, the club had played in the second most seasons (51) and second most games (3,672) and had the second most regular season victories (1,532) in league history. Springfield was also tied for the second most Calder Cup championships of all-time (7).

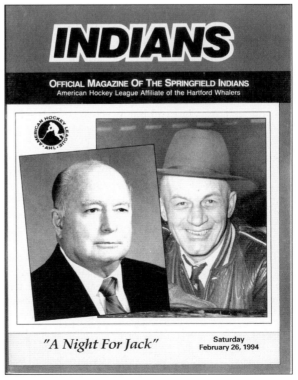

SEVEN

A Whale of a Hockey Town

Major-league hockey came to Springfield in the spring of 1974 when the New England Whalers of the World Hockey Association (WHA) moved to the Eastern States Coliseum from their home at the Boston Garden. The Whalers, an inaugural member of the newly formed WHA in 1972–1973, had encountered financial problems because of competition from the NHL's Boston Bruins. Attendance was less than satisfactory at the Boston Garden in the 1973–1974 season, and Whalers' management began entertaining offers from other cities that coveted the franchise. Hartford, which was building a new arena in the city's civic center, was selected. Instead of waiting until the Hartford building was completed, the Whalers moved their postseason home games to the Eastern States Coliseum, where they played four playoff games. New England split the four postseason games at home (2-2), but lost the Eastern Division semifinals to the Chicago Cougars four games to three.

The Whalers started the 1974–1975 season in Springfield well with a 21-15-2 record, including an 11-2-0 record at the Coliseum. On January 11, 1975, the club christened its new home, the Hartford Civic Center. The Whalers finished the season in first place in their division with a 43-30-5 record. Ron Ryan was in his second season as coach, but was replaced mid-season by Jack Kelley (Whalers coach in 1972–1973). The team was eliminated in the first round by the Minnesota Fighting Saints four games to two.

The New England club returned to Springfield on January 19, 1978, after the roof at the Hartford Civic Center collapsed the day before due to excessive buildup of snow. This time, the WHA team played at the larger Springfield Civic Center, which had about 2,200 more seats than the Eastern States Coliseum. Hall-of-Famer Gordie Howe and his two sons, Mark and Marty, were on the roster, moving from Houston to New England prior to the start of the season. The WHA now had an eight-team single-division format, and New England finished in second place with a 44-31-5 record under coach Harry Neale. The club had an 18-18-2 record while based in Springfield. In the playoffs, the Whalers made their second finals appearance by beating the Edmonton Oilers in the quarterfinals and the Quebec Nordiques in the semifinals,

taking both series four games to one. Unlike their 1972–1973 championship season, they fell short in the finals and were swept (4-0) by Bobby Hull's Winnipeg Jets.

The Springfield Civic Center continued to be the Whalers' home in 1978–1979, while work was being done to repair and enlarge the Hartford Civic Center. The WHA was down to seven teams for its seventh campaign (the Indianapolis Racers later folded, making the circuit only six teams). The Whalers finished in fourth place with a 37-34-9 record behind coach Bill Dineen and his mid-season replacement, Don Blackburn. New England beat the Cincinnati Stingers in the quarterfinals two games to one, but lost in the semifinals to Edmonton in seven games.

The NHL and WHA called off the hockey wars and came to a merger agreement for the 1979–1980 season. The Whalers were one of four WHA teams admitted into the NHL. Entering its NHL era, the team changed the prefix of its name from New England to Hartford in deference to the Boston Bruins. The Whalers compiled a 16-23-10 record while the team was based in Springfield until early February. Hartford played its first game in the renovated Hartford Civic Center on February 6, 1980. The team finished in fourth place in its five-team division with a 27-34-19 record and lost in the preliminary round of the Stanley Cup playoffs to Montreal (three games to none). Season highlights included Blaine Stoughton tying for the most regular season goals in the NHL that season (56) and Gordie Howe returning to the NHL at age 51 and scoring his 800th goal in his 32nd season in the big leagues.

The Whalers lasted 17 more NHL seasons in Hartford before the franchise relocated and became the Carolina Hurricanes following the 1996–1997 season. The team won only one division title (1986–1987) during its NHL era and never made it past the second round of the playoffs. In their 25-year history, the Whalers had an overall (WHA/NHL) regular season record of 815-945-215 (.467 pct). The club won one playoff championship (1972–1973), captured four division titles, and appeared in the postseason in 15 of its 25 seasons. During its time in Springfield, the club had a 92-90-23 (.505 pct) regular season record and a 15-13 (.536 pct) postseason record. Springfield was one of the few cities in hockey history to have a major-league and a minor-league club operate in the same season.

GORDIE HOWE. One of the greatest players of all-time, Gordie spent three seasons with the Whalers (1977–1980), accumulating 180 points, 68 goals, and 178 PIM in 214 games with the franchise. "Mr. Hockey" boasted major-league regular season and postseason totals (NHL/WHA) of 2,589 points and 1,071 goals in 2,421 games. The right winger was inducted into the Hockey Hall of Fame in 1972.

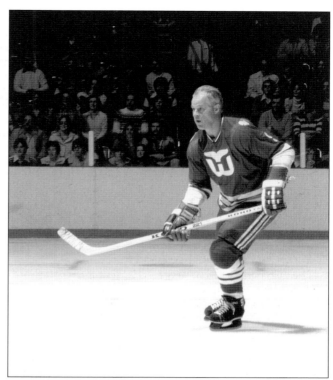

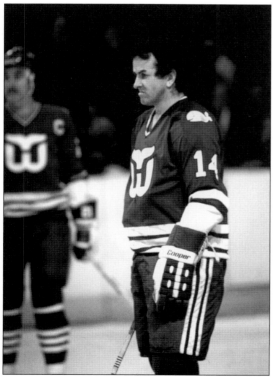

DAVE KEON. Keon was inducted into the Hockey Hall of Fame in 1986. A veteran of 18 NHL seasons (1960–1975, 1979–1982), he had 986 points and 396 goals in 1,296 games. He skated in six seasons with the Whalers (1976–1982), garnering 294 points and 203 assists in 424 games. Keon won four Stanley Cups with Toronto in the 1960s. In his four WHA seasons (1975–1979), the center totaled 291 points and 102 goals in 301 games.

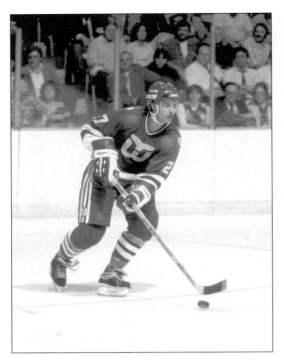

MARTY HOWE. In seven seasons with the Whalers (1977–1982, 1983–1985), Marty had 63 points, 20 goals, and 172 PIM in 260 games. In 1979–1980, with the Springfield Indians, the defenseman collected 13 points and 8 goals in 31 games. He also played in the WHA (1973–1979) and amassed 460 PIM and 184 points in 449 games. During his NHL years (1979–1985), he had 31 points and 99 PIM in 197 games.

MARK HOWE. In five seasons with the Whalers (1977–1982), Mark had 396 points, 123 goals, and 156 PIM in 360 games. He had a 16-year NHL career (1979–1995), in which he registered 742 points and 545 assists in 929 games. The defenseman collected 504 points and 208 goals in 426 games during his six seasons in the WHA (1973–1979). Mark won two Avco World Trophies with Houston (1973–1974 and 1974–1975).

RICK LEY. Ley played nine seasons with the Whalers (1972–1981), accumulating 828 PIM, 267 points, and 228 assists in 559 games. He played in all seven of New England's WHA seasons (1972–1979). The defenseman spent six years in the NHL (1968–1972, 1979–1981) and amassed 528 PIM and 84 points in 310 games. In the NHL, Ley coached both the Whalers (1989–1991) and Vancouver (1994–1996).

LARRY PLEAU. Pleau was elected to the United States Hockey Hall of Fame as an administrator in 2000. He coached the Whalers for five seasons (1980–1983, 1987–1989). During his seven seasons with New England (1972–1979), Pleau totaled 372 points and 157 goals in 468 games. The center skated in five games with the Springfield Indians (1978–1979) and had four points and three assists.

GORDIE ROBERTS. Roberts accumulated 1,582 PIM, 420 points, and 359 assists in 1,097 games during his 15 NHL seasons (1979–1994). The defenseman spent six years with the Whalers (1975–1981) and had 672 PIM, 235 points, and 183 assists in 418 games. His WHA totals, from 1975 to 1979, were 502 PIM and 186 points in 311 games (all with New England).

MIKE ROGERS. Rogers skated in six seasons with the Whalers (1975–1981) and had 467 points and 285 assists in 434 games. A veteran of seven NHL seasons (1979–1986), the center had 519 points and 317 assists in 484 games. During his five-year WHA career (1974–1979), he totaled 367 points and 222 assists in 396 games.

AL SMITH. In 290 games with the Whalers (1972–1975, 1977–1980), Smith had a 3.29 GAA and a 152-108-23 record. In 10 NHL seasons (between 1965 and 1981), he compiled a 3.46 GAA and a 74-99-36 record in 233 games. The goalie put together a 141-98-15 record with a 3.25 GAA in 260 games in the WHA (1972–1975, 1977–1979). Smith had a 3.00 GAA and a 1-1-0 record with Springfield (1979–1980).

ANDRE LACROIX. Lacroix is the all-time WHA leader in points (798), assists (547), and games (551) and is fourth all-time in goals (251). He played two seasons with the Whalers (1978–1980) and had 105 points and 70 assists in 107 games. The center skated in six NHL seasons (1967–1972, 1979–1980), garnering 198 points and 119 assists in 325 games. He played in all seven WHA campaigns (1972–1979).

TIM SHEEHY. Sheehy was inducted into the United States Hockey Hall of Fame in 1997. The right winger skated for Springfield for two seasons (1978–1980) and had 74 points and 34 goals in 101 games. He appeared in five seasons with the Whalers (between 1972 and 1980), collecting 184 points and 92 goals in 244 games. He played 27 games in the NHL (1977–1978 and 1979–1980) and had three points and two goals.

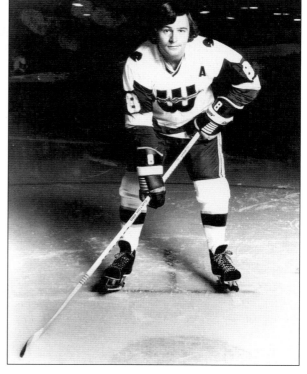

TOM WEBSTER. Webster coached the Springfield Indians in 1981–1982 and went on to coach in four NHL seasons (1986–1987, 1989–1992) with the Rangers and the Kings. In six WHA seasons with the Whalers (1972–1978), the right winger had 425 points, 220 goals, and 241 PIM in 352 games. Webster skated in five NHL seasons (between 1968 and 1980) and had 75 points and 33 goals in 102 games.

EIGHT

The Springfield Falcons

Bruce Landon and Wayne LaChance, along with a group of investors, were granted an AHL expansion team on May 5, 1994. The team was named the Springfield Falcons as a result of a newspaper contest. During their inaugural season, the Falcons began an affiliation with Winnipeg (NHL) that would last until 2003–2004 (Winnipeg moved to Phoenix in 1996–1997). Springfield also formed a working agreement with the NHL's Whalers that season (which lasted through 1996–1997). The club was coached by Paul Gillis. In its first campaign, Springfield finished in fifth place in its six-team division with a 31-37-12 record and did not make the playoffs.

In 1995–1996, the Falcons won the AHL's Northern Division title and the Eastern Conference regular season championship. New coach Kevin McCarthy piloted his club to a 42-27-11 record. Springfield's Manny Legace, a first-team AHL all-star, won the AHL's Baz Bastien Memorial Award and shared Hap Holmes Memorial Award honors with teammate Scott Langkow. In the postseason, the Falcons won their first playoff series against Providence in the opening round (three games to one). In the quarterfinals, Springfield lost to Portland in six games.

Springfield narrowly missed winning its second division title the following season, finishing in second place with a 41-27-12 record. The Falcons carried their regular season momentum into the playoffs as they made it all the way to the Calder Cup semifinals. They beat Portland (three games to two) and Providence (four games to one) during the first two rounds of the postseason. Springfield fell one game short of playing in the Calder Cup finals, losing in the semifinals to Hershey in seven games.

The Falcons captured their second division title and regular season conference championship in 1997–1998 with a 45-28-7 record behind new coach Dave Farrish. The Falcons also set an all-time AHL record for the longest home undefeated streak (24 games, 18-0-6), which started during the second half of the last season. AHL first-team all-star Daniel Briere (center) won the AHL's Red Garrett Memorial Award and was named to the AHL's all-rookie team. Scott Langkow, also selected to the AHL's first all-star team, won the AHL's Baz Bastien Memorial Award. In the opening round of the playoffs, Springfield lost to Worcester three games to one.

During the next two seasons, Springfield hovered around the .500 mark (1998–1999, third place [35-36-9] and 1999–2000, fourth place [33-36-11]) and was eliminated in the first round of the playoffs—losing to Hartford in 1998–1999 three games to none and in 1999–2000 three to two. Los Angeles and Phoenix shared Springfield as their AHL affiliate in 1998–1999. Individual highlights during the two years included Brad Tiley (defense) being named a first-team AHL all-star and receiving the AHL's Eddie Shore Award in 1999–2000, Jean Guy Trudel's (left wing) selection to the AHL's second all-star team in 1999–2000, and Robert Esche's (goalie) pick to the AHL's all-rookie team in 1998–1999.

The Falcons missed the playoffs in consecutive seasons for the first time in team history, as new coach Marc Potvin's team finished in last place in 2000–2001 (29-43-8) and in fourth out of five teams in 2001–2002 (35-43-2). Jean Guy Trudel (left wing) was named to the AHL all-star team in both seasons—first team in 2000–2001 and second team in 2001–2002. Trudel also placed second in AHL scoring (99 points) in 2000–2001, while setting the Falcons' all-time single-season point mark. Phoenix and Tampa Bay split Springfield as their AHL affiliate in 2001–2002 and 2002–2003.

The locals returned to the Calder Cup playoffs in 2002–2003 with a 34-39-7 record and a fourth place finish under new coach Marty McSorley. Springfield won its first playoff series since 1996–1997, sweeping Hartford in a best-of-three qualifying series round. In the conference quarterfinals, the Falcons lost against Hamilton three games to one. The club did not fare as well in McSorley's second season as coach in 2003–2004, finishing in last place with a 26-45-9 record.

Former Springfield Indians player Dirk Graham took over the coaching reigns for the 2004–2005 season. Tampa Bay, the defending Stanley Cup champion, became re-affiliated with the Falcons after a one-year hiatus. The club went 24-56 with a second consecutive last place finish.

In 2005–06, the Falcons have the honor of representing the city during the 80th anniversary of Springfield's first professional hockey team (1926–1927). The Falcons have won two division and two regular season conference championship titles and have an overall regular season record of 375-417-88 (.476 pct). They have participated in the Calder Cup playoffs in 6 of their 11 seasons. As the Falcons enter their 12th season in the AHL, the club carries on one of the greatest traditions in hockey history.

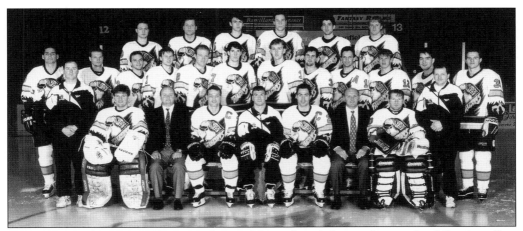

1994–1995 Springfield Falcons. Pictured here, from left to right, are the following: (first row) Stu Lempke, Stephane Beauregard, Bruce Landon, Rob Murray, coach Paul Gillis, John Stevens, Wayne LaChance, Manny Legace, and Ralph Calvanese; (second row) Scott Daniels, Arto Blomsten, Brad Jones, Jason McBain, Mark Deazeley, Mark Visheau, Marek Malik, Kevin Smyth, John Leblanc, Jim Storm, Steve Yule, and Robert Petrovicky; (third row) Bob Wren, Russ Romaniuk, Ravil Gusmanov, Mike Muller, Luciano Borsato, and Dale Junkin.

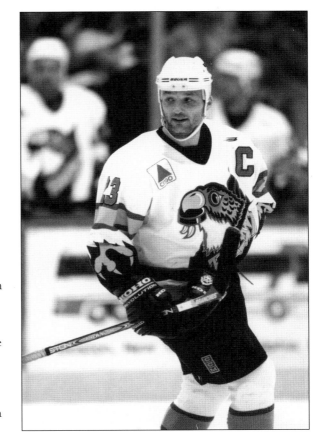

Rob Murray. Murray ranks second all-time in penalty minutes (2,940) in AHL history. The Falcons' PIM king (1,529), he played the most games (501) and seasons (8) in franchise history (1994–2001, 2002–2003). The center also ranks first in assists (157) and second in points (218) on the Falcons' all-time list. In eight NHL seasons (1989–1996, 1998–1999), Murray had 111 PIM and 19 points in 107 games.

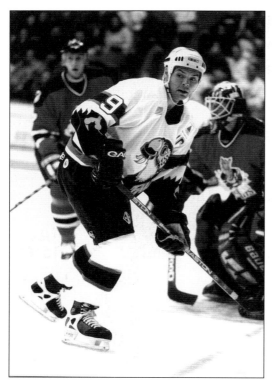

JEAN GUY TRUDEL. Trudel is the Falcons' all-time leader in points (242) and goals (90) and ranks second all-time in assists (152). He also had 252 PIM in 228 games during his three seasons in Springfield (1999–2002). The left winger was named an AHL all-star in each of his Falcons seasons. He holds the Falcons' single-season record for points (99 in 2000–2001) and assists (65 in 2000–2001).

SCOTT LANGKOW. Langkow ranks as the Falcons' all-time leader in wins (63) and is second all-time in GAA (2.77) and games (123). The goalie spent three years in Springfield (1995–1998). In 1997–1998, he set the Falcons' single-season record for wins (30). Langkow played four NHL seasons (1995–1996, 1997–2000) and earned a 4.33 GAA and a 3-12-1 record in 20 games.

DAN FOCHT. Focht played seven seasons with the Falcons (1996–2003) and amassed 641 PIM and 45 points in 298 games. He was the Coyotes' number one (No. 11 overall) pick in the 1996 NHL Entry Draft. The defenseman spent three seasons in the NHL (2001–2004) and had eight points and 145 PIM in 82 games.

BRAD TILEY. Tiley ranks fifth all-time in points (153) in Falcons' history. During his three seasons in Springfield (1997–2000), he had 120 assists and 101 PIM in 209 games. In 1999–2000, the first-team AHL all-star was the winner of the AHL's Eddie Shore Award. Tiley had three stints in the NHL (1997–1999, 2000–2001) and skated in 11 games. The defenseman won a Calder Cup with Milwaukee (2003–2004).

DANIEL BRIERE. Briere is second all-time in goals (88) and assists (129) and third all-time in points (217) in Falcons' history. The center, who played four years in Springfield (1997–2001), became the first Falcons' player to place in the AHL's top 10 in scoring (fourth, 92 points) in 1997–1998. He played seven seasons in the NHL (1997–2004), totaling 223 points, 105 goals, and 228 PIM in 354 games.

ROBERT ESCHE. Esche had a 2.83 GAA, and a 34-29-8 record in 77 games during his three seasons with Springfield (1998–2000, 2001–2002). The netminder spent six years in the NHL (1998–2004) and had a 2.48 GAA and a 51-44-16 record in 128 games. He was awarded the NHL's William Jennings Trophy in 2002–2003. Esche was named to the AHL's all-rookie team in 1998–1999.

TAVIS HANSEN. The right winger skated in six seasons with the Falcons (1995–2001), ranking fourth all-time in points (158) and third all-time in goals (79) in franchise history. He also registered 508 PIM and 79 assists in 298 games. In five NHL seasons (between 1994 and 2001), Hansen had three points and 16 PIM in 34 games.

PATRICK DESROCHERS. DesRochers played more games between the pipes (144) than any other Falcon netminder. During his four seasons in Springfield (1999–2003), DesRochers had a 3.12 GAA and a 52-63-14 record. The netminder had stints in the NHL (2001–2003) with Phoenix and Carolina, compiling a 3.67 GAA and a 2-6-1 record in 11 games. He was the Coyotes' first-round pick (No. 14 overall) in the 1998 NHL Entry Draft.

113

MANNY LEGACE. Legace earned a 2.93 GAA and a 53-45-15 record in 118 games with Springfield (1994–1998). Ranking first in franchise history in shutouts (8) and second in wins (53), the goaltender also set Falcons' single-season records for GAA (2.27) and shutouts (5) in 1995–1996. In the NHL (1998–2004), Legace compiled a 2.22 GAA and a 77-35-18 record in 146 games.

JASON DOIG. Doig spent four years with the Falcons (1995–1999) and amassed 250 PIM, 38 points, and 33 assists in 88 games. He is a veteran of seven NHL seasons (between 1995 and 2004) with Winnipeg, Phoenix, the Rangers, and Washington. The defenseman had 24 points and 285 PIM in 158 NHL games. He played for Calder Cup-winning Hartford in 1999–2000.

Springfield Falcons 10th Anniversary Program. During 2003–2004, the Falcons celebrated their 10th anniversary season. The club also announced its 10th anniversary team, as voted by the fans: Daniel Briere (center), Tavis Hansen (right wing), Jean Guy Trudel (left wing), Dan Focht (defense), Brad Tiley (defense), and Manny Legace (goalie).

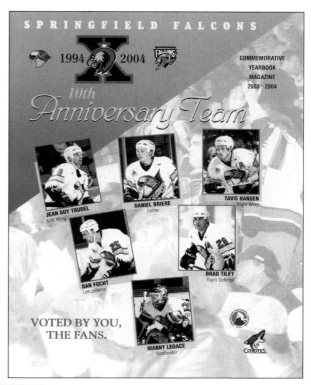

Nikolai Khabibulin. The nine-year NHL veteran (1994–1999, 2000–2004) played for the Falcons during the team's inaugural season. The goaltender had a 3.87 GAA and a 9-9-3 record in 23 games with Springfield. In 476 NHL games, Khabibulin compiled a 2.61 GAA and a 209-187-58 record with 35 shutouts. He was a member of Stanley Cup-winning Tampa Bay in 2003–2004.

JASON MCBAIN. McBain ranks seventh all-time in points (122) in Falcons' history. During his three seasons with Springfield (1994–1997), he also had 87 assists and 175 PIM in 208 games. The defenseman had two stints in the NHL with Hartford (1995–1997) and skated in nine games with the Whalers.

WYATT SMITH. Smith played three seasons with Springfield (1999–2002), registering 107 points and 42 goals in 147 games. He also spent five seasons in the NHL (1999–2004) with Phoenix and Nashville and had 15 points and 8 assists in 83 games. The center played for Calder Cup-winning Milwaukee in 2003–2004.

SYLVAIN DAIGLE. In his four years with Springfield (1996–2000), the goaltender compiled a 3.04 GAA and a 24-30-6 record in 72 games. Daigle was a member of three UHL Colonial Cup-winning teams with Muskegon (2001–2002, 2003–2004, and 2004–2005) and was the UHL's playoff MVP in 2003–2004. He also earned UHL Best Goaltender honors in 2001–2002.

JASON JASPERS. A veteran of four seasons with the Falcons (2001–2005), Jaspers compiled 134 points (sixth all-time in Falcons' history), 77 assists, and 213 PIM in 240 games. In the center's three stints in the NHL (2001–2004), he totaled one point and six PIM in nine games.

ERIK WESTRUM. In his three seasons in Springfield (2001–2004), Westrum garnered 106 points, 69 assists, and 272 PIM in 199 games. The center had a stint in the NHL with Phoenix (2003–2004) and had two points, one goal, and 20 PIM in 15 games.

JEAN MARC PELLETIER. Pelletier boasted the best career GAA (2.63) of any Falcon netminder in his three seasons between the pipes for Springfield (2002–2005). He also compiled a 24-41-10 record in 80 games. The goaltender played seven NHL games over three years (1998–1999, 2002–2004) and earned a 3.91 GAA and a 1-4-0 record.

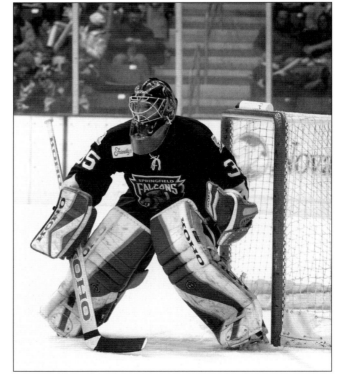

NINE

Other Teams and Leagues

When Eddie Shore moved his AHL team to Syracuse prior to the 1951–1952 season, he put an Eastern Amateur Hockey League (EAHL) expansion team in Springfield. The new Springfield Indians became a farm team for Syracuse, as Shore moved his players up to his AHL squad when needed. Jack Butterfield was the general manager of the expansion Indians team during all three of its seasons. The EAHL, which originated in December 1933, was composed of eight teams in 1951–1952. Players in the EAHL were paid a salary, but were classified as amateurs. United States Hockey Hall-of-Famer and former Springfield Indian Bob Dill piloted Shore's new team. The first season was a success, with a fourth-place finish (33-29-4) and a playoff berth. In the opening round against the first-place Johnstown Jets, the Indians were swept in three games. Springfield's Vern Pachal led the EAHL in goals (51).

In 1952–1953, former AHL Indian Doug McMurdy became coach. Springfield captured the EAHL's regular season title (39-19-2) and was awarded the Walker Cup. Three players—Bill Jones (second, 105 points), Vern Pachal (third, 102 points), and Vern Jones (fourth, 95 points)—placed in the league's top 10 in scoring. Vern Jones led the loop in goals (56) and Bill Jones (78) in assists. In the postseason, Springfield beat the New Haven Nutmegs four games to one in the opening round semifinal. They battled Johnstown in the finals for the Atlantic City Boardwalk Trophy, but fell short four games to two.

The EAHL suspended operations for the 1953–1954 season, and Springfield joined the Quebec Hockey League (QHL). The QHL, which became a professional league in 1953–1954, was previously known as the Quebec Major Hockey League (1950–1953) and the Quebec Senior Hockey League (1945–1950). Teams in the QHL competed for the O'Connell Trophy in the playoff championship. The Indians were the only United States-based team in the league that season. McMurdy returned as coach as the level of competition rose in the Indians' new league. The club did not fare well in its new circuit, finishing last with a 25-40-7 record.

In 1954–1955, Shore moved his AHL club back to Springfield after a three-year hiatus in Syracuse, and the QHL Indians disbanded. The EAHL/QHL Indians had an overall record of

97-88-13 (.523) during three seasons (1951–1954). Bill Jones is the all-time team leader in points (200) and assists (137), while Vern Pachal scored the most goals (104) for the club. Graham Hastings appeared in the most games (172).

The EAHL (known as the Eastern Hockey League [EHL] since the 1954–1955 season) resurfaced in Springfield in 1972–1973. The New Haven Blades, members of the EHL since the 1954–1955 season, moved to the Eastern States Coliseum for the 1972–1973 campaign and were renamed the New England Blades. That year, the city of New Haven was granted an AHL franchise—the New Haven Nighthawks—resulting in the move of the Blades. The plan was for the Blades to stay in Springfield for two years and then move to Hartford in 1974–1975, when the Hartford Civic Center was scheduled to be built. Rich Green served as coach of the team. Since the 1963–1964 season, teams in the EHL were awarded the Walker Cup for the playoff championship.

The EHL had scheduled an all-time-high 76-game season, but New England folded in mid-season after only 24 games (9-13-2). Trouble started for the Blades in early November when five players quit the team, soon followed by the WHA's New England Whalers terminating their working agreement with the club. The club needed 2,500 fans per game to break even, but was averaging 1,600 and crowds were steadily shrinking as fans remained loyal to Springfield's AHL team. The Blades' final game was on November 26—a 4-0 win before only 776 fans against the Jersey Devils. The team suspended operations that night, after an unsuccessful proposal to move to Binghamton, New York, and officially disbanded five days later. Many of the Blades finished the season with other EHL teams. Notable players with the club included Warren "Butch" Williams, who played in the NHL and WHA; Don "Toot" Cahoon, head hockey coach at Princeton University (1992–1993 and 1994–2000) and the University of Massachusetts at Amherst (2000–2005); and Mike Gilligan, head hockey coach at the University of Vermont (1984–2003).

In May 1973, the EHL dissolved into two new leagues: the North American Hockey League (NAHL) and the Southern Hockey League (SHL). At the time, the EHL was the oldest minor hockey league in North America, having begun in 1933.

KEN SCHINKEL. Schinkel started his professional hockey career with Springfield in 1953–1954 and had 19 points and 5 goals in 39 games. He played 12 years in the NHL (1959–1964, 1966–1973), registering 325 points and 127 goals in 636 games. The right winger skated in five AHL seasons in Springfield (1955–1959, 1960–1961) and had 236 points and 107 goals in 289 games. (SHHOF.)

DOUG MCMURDY. McMurdy played three seasons for the EAHL/QHL Indians (1951–1954) and was a player and coach in 1952–1953 and 1953–1954. The center had 108 points and 69 assists in 98 games during those three seasons. McMurdy also played six seasons with the AHL Indians (1948–1951, 1954–1957) and had 267 points and 85 goals in 286 games. He ranks ninth all-time in assists (182) in Indians/Kings history. (SHHOF.)

VERN KAISER

VERN KAISER. The defenseman had prior NHL experience with Montreal (1950–1951) before coming to the QHL Indians. In 1953–1954, Kaiser totaled 36 points and 14 goals with Springfield. He also played two seasons in the AHL (1948–1950) with Springfield, garnering 80 points and 44 goals in 125 games.

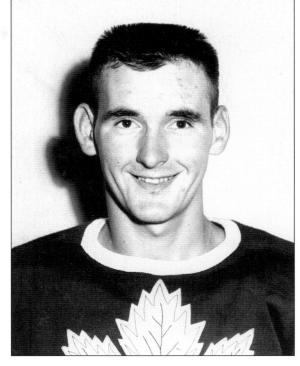

JOHN HENDERSON. Henderson was a member of the Whitby Dunlops' 1957–1958 World Championship and 1956–1957 Allan Cup teams. He had an 8-11-3 record and a 4.11 GAA in 22 games for Springfield (1953–1954). He played two seasons (1954–1956) with Boston and tended goal for a Patrick Cup (WHL), Adams Cup (CPHL), and Calder Cup (AHL) winning team.

WALT ATANAS. Atanas had 22 points and 7 goals in 18 games for the QHL Indians in 1953–1954. During the next two seasons, Atanas skated with Shore's AHL club, producing 126 points and 53 goals in 118 games. The right winger won a Calder Cup with Buffalo (1943–1944) and played one season in the NHL with New York (1944–1945).

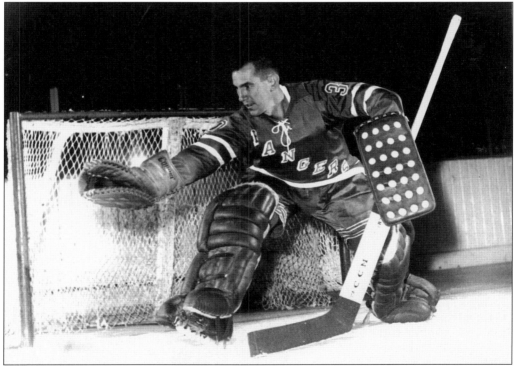

DON SIMMONS. Simmons was between the pipes in both of the Indians' EAHL seasons (1951–1953) and had a 49-29-3 record with a 3.50 GAA in 81 games. He was a second-team EAHL all-star in 1951–1952 and 1952–1953. During 11 NHL campaigns, the goaltender had a 2.89 GAA and a 101-100-41 record in 248 games. He also played with Springfield in the AHL (1954–1957).

DON PERRY. Perry accumulated the third most PIM (1,935) and appeared in the fourth most games (952) in EHL history. He was also the all-time leader in PIM (352) for the Indians during his three seasons with the club (1951–1954). The defenseman later coached in the NHL with Los Angeles (1981–1984). He was a member of two EHL playoff championship teams: New Haven (1955–1956) and Long Island (1964–1965).

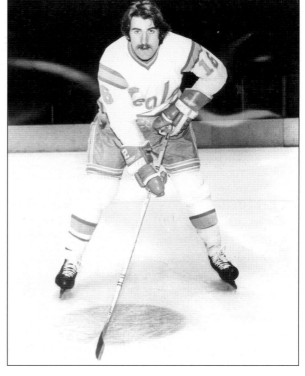

WARREN "BUTCH" WILLIAMS. The only New England Blade to skate in the NHL, Williams played three seasons (1973–1976) between St. Louis and California. He had 49 points, 14 goals, and 131 PIM in 108 NHL games. The right winger also spent one season in the WHA with Edmonton (1976–1977), garnering 13 points and 16 PIM in 29 games.

TEN

Eddie Shore Is Springfield Hockey

Eddie Shore, "the Edmonton Express," was associated with Springfield hockey for parts of five decades (1939–1976). He was a player, coach, manager, owner, and savior of the Springfield Indians. The Springfield Falcons retired his number 2 jersey to honor his accomplishments, contributions, and dedication to hockey in the city of Springfield, as well as the sport of hockey as a whole. His number was also retired by the Boston Bruins. In 1947, Shore was inducted into the Hockey Hall of Fame and, in 1970, was awarded the NHL's Lester Patrick Trophy, an achievement award for "outstanding service to hockey in the United States." In 1958–1959, the AHL instituted the Eddie Shore Award to be given annually to the player chosen as the best defenseman in the league. The NHL legend is one of the few individuals in the history of hockey to have a significant impact on both the major- and minor-league levels of the game.

On July 11, 1939, Shore bought the Springfield Indians team from J. Lucien Garneau, stating that Springfield appealed to him as a hockey center to such an extent that he was willing to buy the franchise. The Edmonton Express built the Indians into a solid AHL team in the early 1940s.

Shore's dedication to his players was evident when he found them a new place to play during World War II. During the war, the Indians' home rink was used by the U.S. Army Quartermaster Corps. Shore negotiated a deal with Louis Jacobs, the owner of the Buffalo Bisons (AHL), which allowed Shore to transfer his players to Buffalo and take control of the franchise from 1942 to 1945. Shore also served as general manager of the Bisons. Instead of being unemployed for four seasons, Shore's players won back-to-back Calder Cups in Buffalo in 1942–1943 and 1943–1944. The Edmonton Express then severed his partnership with Jacobs and owned and operated an AHL team in New Haven in 1945–1946: the New Haven Eagles. The Hall-of-Famer immediately returned to Springfield in 1946–1947 when the Eastern States Coliseum became available.

When the AHL Board of Governors persuaded Eddie Shore to move the Indians to Syracuse, New York, he did not leave Springfield without hockey. The NHL legend put a new Springfield Indians team (EAHL/QHL) on the ice from 1951 to 1954.

Shore built the greatest dynasty in the history of the AHL in the early 1960s. The Indians were the only team to ever win three straight Calder Cup championships (1960, 1961, and 1962). The Indians' winning reputation and great tradition lured NHL expansion owner Jack Kent Cooke to approach Shore to purchase the rights to his players in 1967. When Shore sold the Indians and retired from hockey in the summer of 1976, the team was regarded as one of the most successful in AHL history. At the time, Springfield was tied for the second most Calder Cup championships with five (1960, 1961, 1962, 1971, and 1975).

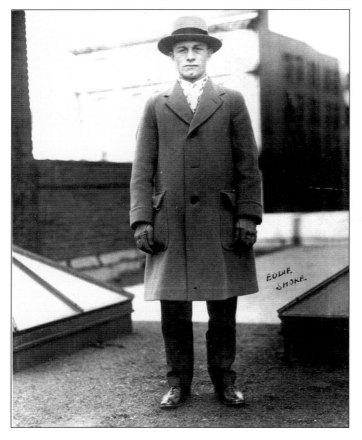

EDDIE SHORE. Shore began his major-league hockey career with the Regina Caps of the Western Canada Hockey League (WCHL) in 1924–1925. He spent one more season in the league (now known as the Western Hockey League) in 1925–1926 with the Edmonton Eskimos, before entering the NHL the following season.

EIGHT-TIME NHL ALL-STAR. Eddie Shore anchored the defense on Stanley Cup-winning teams in Boston in 1928–1929 and 1938–1939 and helped the Bruins to nine first-place finishes. When the NHL began selecting an all-star team in 1930–1931, Shore was named eight times in the first nine years (seven times to the first team), missing out only in 1936–1937 when he had an injury.

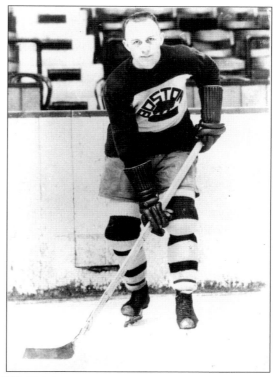

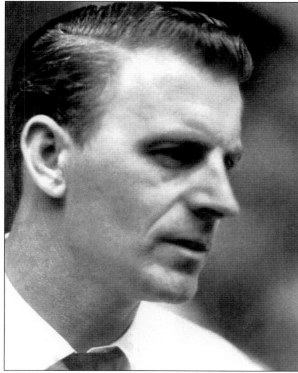

EDDIE "TED" SHORE JR. Ted was associated with the Indians' franchise from 1939 to 1976, coaching the team for part of the 1966–1967 season. Shore also served in several other capacities with the Springfield club, including vice-president, board of governors representative, general manager, business manager, advertising and promotions manager, accountant, editor and publisher, ticket seller, and Zamboni machine operator. (SHHOF.)

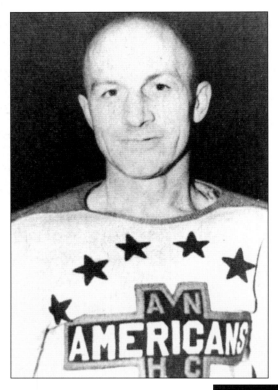

No. 10 of All-Time. Shore was selected 10th in the *Hockey News*'s Top 100 Players of All-Time. He ranked second on the list among defenseman, and is the highest ranked pre-World War II player. The NHL legend was the only defenseman in NHL history to win four Hart Trophies (1932–1933, 1934–1935, 1935–1936, and 1937–1938). He had 284 points, 179 assists, and 1,047 PIM in 550 NHL games. In the Stanley Cup playoffs, Shore had 19 points, 13 assists, and 181 PIM in 55 games.

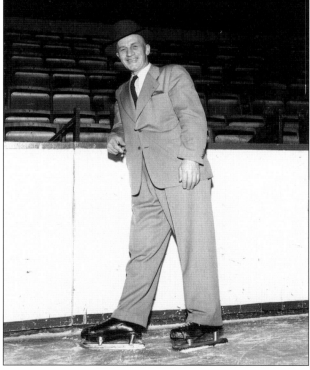

Giving Back. Shore gave back to the Springfield community by helping develop youth leagues, hockey clinics for kids, and amateur and high school leagues. The hockey legend provided ice time at the Coliseum for children. Full of patience when teaching kids about hockey, Shore would take time to graciously instruct children on the ice.